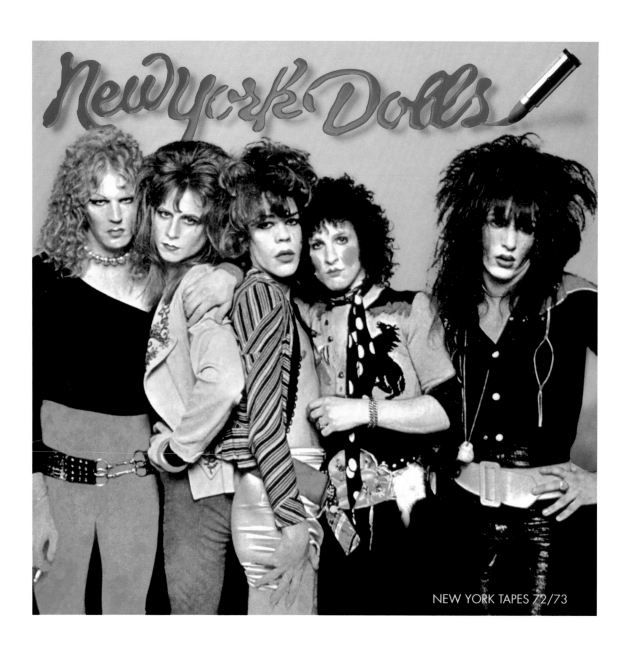

NEW YORK TAPES 72/73

New York Dolls
New York Tapes 72 / 73

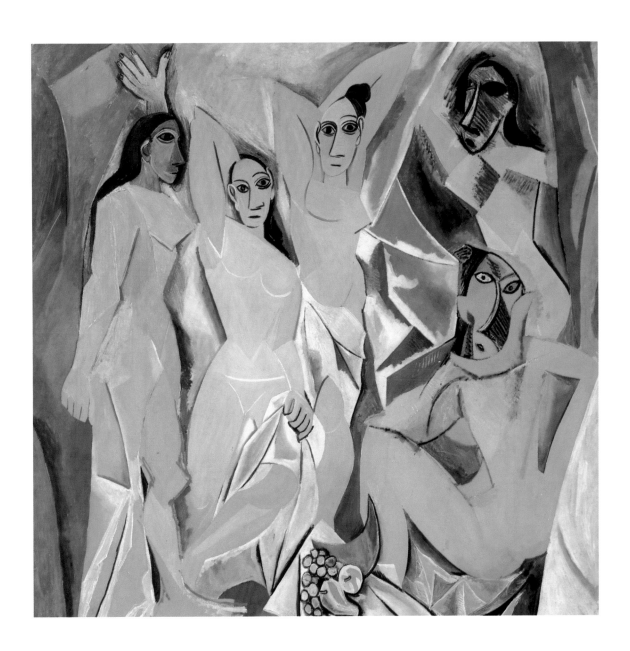

Pablo Picasso

Les Demoiselles d'Avignon, 1907

REBECCA WARREN

CONTENTS / INHALT

9 **INTRODUCTION**
Beatrix Ruf

13 **EINLEITUNG**
Beatrix Ruf

19 **INTERVIEW**
Carl Freedman / Rebecca Warren

29 **INTERVIEW**
Carl Freedman / Rebecca Warren

41 **DARK PASSAGE**
Gregorio Magnani

57 **DARK PASSAGE**
Gregorio Magnani

90 **BIOGRAPHY / BIOGRAFIE**
BIBLIOGRAPHY / BIBLIOGRAFIE

92 **LIST OF WORKS / ABBILDUNGSVERZEICHNIS**

INTRODUCTION

Beatrix Ruf

Large-size figures of unfired clay, which grotesquely exaggerate the characteristic traits and trademarks of female sexuality such as breasts, calves and buttocks, have made a name for British artist Rebecca Warren. This catalogue documents her first institutional solo-show, entitled *Dark Passage*, at the Kunsthalle Zurich. Rebecca Warren presented almost all new works: one group of her most recent large figurines together with 13 small-format clay scenes on pedestals, and three-dimensional collages in showcases.

/

Rebecca Warren enjoys juggling with references and likes using existing imagery. The exhibition title *Dark Passage* comes from a film produced in 1947, in which the Hollywood dream couple Humphrey Bogart and Lauren Bacall both star. Nevertheless no direct reference is meant to adhere. For those who know the film and remember its cinematographic distinctiveness, the plot is told through the tunnel-like restricted view of Humphrey Bogart, whose head is wrapped in gauze. (The plot runs as follows: accused of murdering his wife the protagonist escapes from prison and has a plastic surgeon create a new face for him so he can prove his innocence under a new identity.) One cannot resist making a direct link to the image the artist used for the exhibition poster: the photo stems from the photo archives of the National

Library in Canada: we see a tunnel for a new railroad line in the Rocky Mountains – land reclamation, male pioneering, heroic legends, utopia-driven ideas, the manipulation of nature by men and technology, and of course the evocation of sexual images.

/

Titles, quotations and references all stand for Rebecca Warren's cosmos of associations and deferrals, which her works can and should trigger and through this create new images and stories. Her oeuvre references a veritable array of male masters from the history of art: Degas, Rodin, Boccioni, Picasso, Fontana, the German Expressionists, and Neo-Expressionists as well as Robert Crumb. It also brings to mind the works by a younger generation of artists such as Martin Kippenberger or Fischli & Weiss, and the hostile and striking aggressiveness but substantive subtlety by artist colleague Sarah Lucas.

/

Rebecca Warren's art likewise unites popular and high culture, feministic and psychological debate. All this is not primarily some ironic statement or the offended criticism fired by the traditional male portrayal of the female body. Warren is not actually concerned with these male artists as such, seeking rather to position herself directly as the next in the traditional lineage – maybe the way Kathryn Bigelow can do a Hollywood thriller and at the same time intelligently misrepresent male clichés. Her large "women" seem to confidently and brazenly flaunt the insignia of their desirability. Her work is akin to an exciting thriller on the topics of figurative portrayal, representation and fiction.

/

In 2003, the artist exhibited a group of six large-sized unfired clay figures entitled *She*. Once again, Rebecca Warren took the title from the world of the silver screen, or rather a novel by author H. Rider Haggard, which has, since the silent movie era, inspired numerous film scripts, and was used for various screen adaptations. Warren references the 1965 film production in which Ursula Andress plays Ayesha. Moving in a post-apocalyptic world in which she depicts the epitome of breathtaking female beauty and strength, she helps two brothers recover their kidnapped sister. The picture for this exhibition showed

Sigmund Freud surrounded by his male colleagues. The six gigantic *She* figures stand on their own wooden trolleys, a classic means of transport ("She Devils on Wheels" as Sylvie Fleury would probably call them…). The sculptures' surfaces have a coarse, unworked appearance; at times you feel you have before you the original lump of clay. The absence of heads in the figurines is offset by their enormous breasts, undulating, arm-like ornaments, generous calves, and above all the abundance of flesh and clichés originating from the artificial world of bosom wonders. By contrast, another gigantic unfired clay sculpture biends the fantasies of Robert Crumb and Helmut Newton: *Helmut Crumb* (1998). The female bodies are reduced to their legs. Two pairs of legs together with the lower torso are positioned on a single pedestal like perverted double bridges; the Robert Crumb version is aggressive, the Newton-inspired legs aesthetically sexualised. Also "male" figures find their way into the work of the artist such as the small, here exceptionally cast as bronze, cube on wheels, which can easily be pushed around in the room, or the large, heavy and shapeless clay figure *Private Schmidt* from 2004, where the phallic symbols have been made comically grotesque.

/

Alongside these enormous women in clay, Warren creates smaller-sized clay works in her studio, some of which she paints with coloured glaze. All stand on pedestals, which in many instances are painted in a saccharine hue that advances the idea underlying the work. This group includes, for example, the *Totems* made in 2002, unfired clay figures, smaller versions of the *She* works and groups of figurines, from whose undefined mass of clay erotic scenes, figures and landscapes evolve. These are often applied with a sweetish colouring, an intervention which, interplaying with the opposing and often drastic and aggressive content of the scenes, creates an intense contrast.

/

In the artist's three-dimensional vitrine-collages featuring pieces of wood, wire, cotton wool balls, neon lights and paraphernalia of diverse origins, the same mindset unravels as in the clay figures infused by "female" perception and interpretation. In the three-dimensional

collages, the pedestal is again an integral part of the work, as is the case in *Bitch Magic: The Musical* (2001-2003), in which an enormous Perspex hood is placed over a collage of objects – pedestal included – and is thus transformed into a new "pedestal" for a gold-painted plaster form. All vitrine-collages are accumulations of items, which exude an intimate fiction and defy the logic of composition. *Every Aspect of Bitch Magic* (1996), for example, combines a glass containing a dead bee, an elastic hair-band, a shell, a green piece of glass, a pair of panties and a safety needle on a pedestal. A wooden frame, which was to serve as a model for a Perspex cover, was never replaced – instead, a white envelope leans against it, and over this another pair of panties has been pulled crotch of which has been lovingly decorated with washing machine fuzz.

/

Rebecca Warren sees her collages as "magical objects". Like her crudely made figurines they also evoke a sense of the ever present doubtful authenticity of the artist's studio. One believes one is in the studio or almost sensing the presence of the "model" in the room, but all of this is a more fictional, maybe virtual situation, a dense universe of possibilities, which composes itself for the purpose of transitory, continuously regenerating contents.

/

In all of Rebecca Warren's works the feasibility of the representation of the body as well as of the creative act per se becomes manifest as a monstrosity.

EINLEITUNG

Beatrix Ruf

Mit grossformatigen Figuren aus ungebranntem Ton, die die Erkennungs- und Vermarktungszeichen weiblicher Sexualität wie Busen, Waden und Hintern ins Monströse überzeichnen, hat sich die britische Künstlerin Rebecca Warren einen Namen gemacht. Ihre mit diesem Katalog dokumentierte Ausstellung in der Kunsthalle Zürich mit dem Titel *Dark Passage* war die erste institutionelle Einzelausstellung der Künstlerin. Rebecca Warren zeigte fast ausschliesslich neue Arbeiten: eine Gruppe von Grossfigurinen, eine dreizehn Werke umfassende Gruppe von kleinformatigen Tonszenen auf Sockeln sowie dreidimensionale Collagen in Vitrinen und auf Sockeln.

/

Rebecca Warren jongliert gerne mit Referenzen und bedient sich gerne an bekannten Bildern: Der Ausstellungstitel *Dark Passage* stammt von einem 1947 produzierten Film, in dem das Hollywood-Traumpaar Humphrey Bogart und Lauren Bacall agiert. Dennoch ist keine direkte Referenz gemeint. Wenn man den Film jedoch kennt, und sich dessen kinematographische Besonderheit in Erinnerung ruft, dass ein Grossteil des Plots durch den tunnelgleichen, durch Mullbinden eingeschränkten Blick Humphrey Bogarts erzählt wird (die sehr reduziert dargestellte Erzählung: Ein des Mordes an seiner Frau angeklagter Protagonist flieht aus dem Gefängnis und lässt sich

von einem Chirurgen ein neues Gesicht machen, um unter neuer Identität seine eigene Unschuld beweisen zu können), kann man sich auch nicht dagegen wehren, eine direkte Verbindung zum Bild herzustellen, das sich die Künstlerin als Einladungsposter gewählt hat: Das Foto stammt aus dem Archiv der National Library in Kanada und zeigt den Tunneldurchstich für eine neue Eisenbahnlinie in den Rocky Mountains. Es gemahnt an Landgewinnung, männliche Pioniertaten, Heldenmythen, Machbarkeitsideale, die Manipulation der Natur durch den Menschen und die Technologie und evoziert natürlich auch sexuelle Bilder.

/

Titel, Zitate, Referenzen stehen bei Rebecca Warren für den Kosmos an Assoziationen und Verweisen, die ihre Arbeiten auslösen sollen und können, und die sich durch diese zu neuen Bildern und Erzählungen zusammensetzen. Ihr Werk bedient sich unumwunden an einer männlichen Ahnenreihe der Kunstgeschichte: Degas, Rodin, Boccioni, Picasso, Fontana, die Deutschen Expressionisten und auch Neo-Expressionisten ebenso wie Robert Crumb treten auf. Erinnerungen werden auch geweckt an die Arbeiten einer jüngeren Künstlergeneration wie Martin Kippenberger oder Fischli & Weiss und die offensive und plakative Angriffigkeit und zugleich inhaltliche Subtilität der Arbeiten ihrer Künstlerkollegin Sarah Lucas.

/

In Rebecca Warrens Werk versammelt sich Populärkultur wie Hochkultur, feministischer wie psychologischer Diskurs. Aber weder Ironie noch gekränkte Kritik an der Tradition männlicher Darstellungen des weiblichen Körpers stehen im Vordergrund. Warren schert sich nicht wirklich um die männlichen Vorfahren, sondern setzt sich in deren direkte Linie – vielleicht so, wie Kathryn Bigelow Hollywood-Thriller drehen und das männliche Klischee intelligent verdrehen kann: Grossformatig und die Insignien der Begehrlichkeit krass und selbstbewusst überzeichnend, kommen Warrens "Damen" daher. Ein spannender Krimi über die Themen figürlicher Darstellung, Repräsentation und Fiktion breitet sich aus.

/

2003 zeigte die Künstlerin in London eine Gruppe von sechs gross-
formatigen ungebrannten Tonfiguren mit dem Titel *She*. Den Titel
der Werkgruppe nahm Rebecca Warren wiederum aus der Filmwelt,
respektive von einer Novelle des Autors H. Rider Haggard, die seit
der Stummfilmzeit in zahlreichen Versionen als Filmskript umgesetzt
wurde und als Vorlage für verschiedene Verfilmungen diente. Warren
bezog sich auf die 1965 realisierte Produktion, in der Ursula Andress
in der Rolle der Ayesha in einer postapokalyptischen Welt als Inbegriff
von atemberaubender weiblicher Schönheit und Stärke figuriert und
zwei Brüdern beisteht, deren entführte Schwester wieder zu finden.
Die Einladungskarte zu dieser Ausstellung zeigte Sigmund Freud im
Kreise seiner männlichen Kollegen. Die sechs gigantischen *She*-Figuren
standen auf Holzbrettern mit Rädern, gebräuchlichen Transporthunden
also („She Devils on Wheels" wie Sylvie Fleury vielleicht sagen wür-
de). Die Oberflächen der Plastiken sind grob und unbearbeitet;
zuweilen meint man, die originale Form des Tonklumpens vor sich zu
haben. Die Figurinen haben keine Köpfe, dafür ondulierte armartige
Ornamente, riesige Brüste, ausgreifende Waden und vor allem: viel
Körper und Klischees der Busenwunderfabrik. Eine andere grosse
ungebrannte Tonskulptur wiederum vermischt die Phantasien von
Robert Crumb und Helmut Newton: *Helmut Crumb* (1998). Die
weiblichen Körper sind auf die Beine reduziert. Zwei Beinpaare mit
Unterleib stehen zusammen auf einem Sockel, wie pervertierte Brü-
ckenpaare; die Robert Crumb-Version offensiv, die Newton-Anleihe
ästhetisiert sexuell.

/

Aber auch "männliche" Figuren finden sich im Werk der Künstlerin:
der kleine, ausnahmsweise in Bronze realisierte Kubus auf Rädern,
den man so schön im Raum herumschubsen kann, oder die grosse,
schwere und unförmige Tonskulptur *Private Schmidt* von 2004, deren
phallische Insignien ins grotesk Komische verkehrt sind.

/

Parallel zu den grossen "Tondamen" entstehen im Atelier der Künst-
lerin immer auch kleinformatigere Tonarbeiten, die zum Teil mit far-
biger Glasur bemalt sind. Diese stehen alle auf Sockeln, die häufig mit

einer zusätzlichen, die Arbeit weiterspinnenden Bonbonfarbe bemalt sind. Zu dieser Werkgruppe gehören zum Beispiel die *Totems* von 2002, eine Gruppe ungebrannter Tonfiguren, kleinere Versionen der *She*-Arbeiten und Figurinengruppen, aus deren undefinierter Tonmasse sich erotische Szenen, Figuren, Landschaften formulieren. Diese sind meist mit Farbe kompositorisch behandelt, ein Eingriff, der mit seiner meist süsslichen Farbigkeit im Zusammenspiel mit den oft drastischen und erotisch aggressiven Inhalten der Szenen einen Kontrast produziert.
/
In den dreidimensionalen Vitrinen-Collagen der Künstlerin aus Holzstücken, Draht, Wattebäuschen, Neonlichtern und Paraphrenalien unterschiedlichster Herkunft, breitet sich die gleiche mentale Landschaft aus, wie bei den von "weiblicher" Wahrnehmung und Lesart durchdrungenen Tonfigurinen. Auch bei den dreidimensionalen Collagen ist der Sockel integraler Bestandteil des Werkes, wie zum Beispiel in der Arbeit *Bitch Magic: The Musical* (2001–03), bei der eine riesige Plexiglashaube über eine Collage von Objekten inklusive ihres Sockels gestülpt ist und so zum neuen "Sockel" für eine goldbemalte Gipsform wird.
/
Alle Vitrinen-Collagen der Künstlerin sind Akkumulationen von Gegenständen, die eine intime Fiktion ausbreiten und sich der Logik von Komposition entgegenstellen. *Every Aspect of Bitch Magic* von 1996 etwa versammelt ein Glas, in dem eine tote Biene liegt, ein Gummihaarband, eine Muschel, ein grünes Glasstück, eine Unterhose und eine Sicherheitsnadel auf einem Sockel. Ein Holzrahmen, der als Vorlage für eine Plexiglashaube dienen sollte wurde nie mehr ausgewechselt – stattdessen lehnt daran nun ein weisser Umschlag, über den nochmals eine Unterhose gezogen wurde, deren Schritt liebevoll mit Waschmaschinenfusseln dekoriert ist.
/
Rebecca Warren betrachtet ihre Collagen als „magische" Objekte. Sie evozieren – ebenso wie ihre krude bearbeiteten Figurinen – die immer auch zweifelhafte Authentizität des Künstlerstudios. Man meint im Atelier zu sein oder das „Modell" noch im Raum anwesend zu haben,

aber es handelt sich um virtuelle, fiktive Situationen, um einen dichten Kosmos von Möglichkeiten, der sich nur transitorisch zusammensetzt, um erneuernde Inhalte zu kreieren.

/

In allen Arbeiten Rebecca Warrens manifestiert sich die Monstrosität der Möglichkeit einer Abbildung überhaupt, sei es die des Körpers oder die des kreativen Aktes an sich.

INTERVIEW

Carl Freedman / Rebecca Warren

Can you tell me about the connection between Freud, The New York Dolls, and *Les Demoiselles d'Avignon*?

It begins with there being a strange similarity between the images, as if they are different versions of the same thing. And it might be an instinctive response to put them in chronological order, but it's not certain which is the progenitor, and who or what is doing the determining.

/

The Freud image and *Les Demoiselles d'Avignon* were first brought together for the exhibition *She*.

I had the title *She* in my head ever since seeing the Hammer horror film. In it Ursula Andress plays an archetypal beautiful woman who never gets old; she's untouchable and omnipotent, and expresses her displeasure by dropping her subjects into a pit of fire. Ultimately, however, her powers go into reverse, and in front of all the men who have held her up as their ultimate fantasy, she degenerates into an ancient hag.

/

/

/

/

How closely were the sculptures in *She* based on *Les Demoiselles*?
Initially I decided to make the five figures, but I kept going and it became eleven, and from there on I chose the most degenerate ones. I liked the idea of juxtaposing these mad and ugly sculptures with the picture of Freud and his cohorts.
/

The issue of the male gaze often arises in discussions about your work, that you are engaging with some form of gender politics.
I don't like to think that I am working in such a prescribed way. My position in it all is deliberately precarious. With *She* it's not as though the sculptures are inversions or reversals. They are made things with their own made sexual qualities.
/

In a single work you refer to Helmut Newton and R. Crumb.
Helmut Crumb began with an R. Crumb cartoon called *Girls, Girls, Girls*. It starts with a woman who keeps changing, at one point becoming his mother, and ends up as a cunt on legs. The final image was like monumental architecture. I decided to try and make it just as that, as something three-dimensional.
/

And how did Helmut Newton become part of it?
I was looking at Martin Kippenberger's *Helmut Newton for the Poor* — Kippenberger dressed as a peasant woman with a headscarf, standing in a room with cheap furniture—and I liked the translation of Bavarian opulence and taking that translation further into a material like clay. I had Newton's book *White Women* and was looking through it and I was convinced they all looked like homunculi. There's one photo in that book called *In My Apartment*, which had an obvious relationship with the figure in the Crumb cartoon, and from that I made the other half of the sculpture, keeping that sense of shrunken scale.
/
/
/
/
/

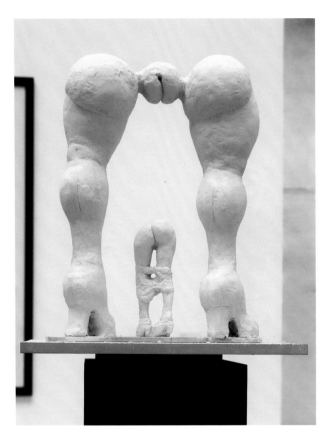

Helmut Crumb, 1998

<u>How do you see your relationship to the artists you are referring to?</u>
It's one of influence and allowing myself to admit to being influenced. Of course there is a real hardcore drive of iconoclasm in there too – that basic idea of wanting to kill your father, and general oedipal revolt. It's also about finding a way to be expressive. Expression is perceived as a problem. One way of negotiating that is to re-use existing idioms that are accepted as being expressive, for instance Auguste Rodin, Willem de Kooning or Otto Dix.
/

<u>Is this a way of abnegating responsibility?</u>
Well on the one hand yes, but I am also acknowledging a debt.
/
/
/

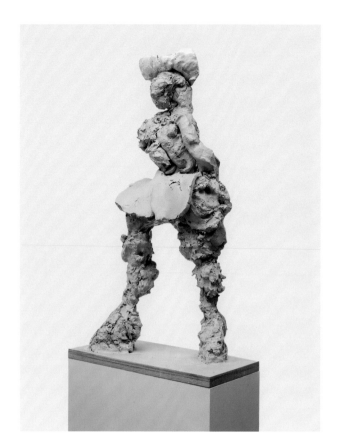

Pony, 2003

You seem happy with being perceived as removed from the position of the author, to the extent that you've said you'd like the work to look like it has been made by a frustrated provincial woodwork teacher. What's conspicuous is that all the artist guises you take on are male.

Yes, it means I can inhabit territories that are understood as being dodgy. It's not a matter of being didactic in any way. It's looking at things I am actually attracted to and working out what and where those allegiances come from.

/
/
/
/
/
/

<u>What attracted you to Degas?</u>

The Little Dancer. It has quite an extreme mutability, from how it was originally reviled to becoming almost anodyne; from it being a unique wax sculpture which Degas kept with him in his studio all his life and wouldn't cast in bronze, to it being posthumously cast and ending up in museums all around the world, and becoming so familiar in that state that the original wax sculpture is perceived as an anomaly. It didn't help its original reception that Degas showed it alongside pastel drawings of criminals, giving them all overly pronounced sloping foreheads and jutting chins. And then showing the sculpture in a vitrine, which was also quite strange and unusual, suggesting that this teenage girl was some kind of specimen. That's quite perverse. Making something so purposely unappealing, but then being so attached to it that he kept it with him till he died.

/

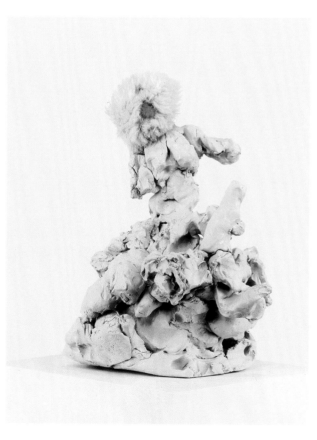

Delacroix, 2003

When it was exhibited it was as much an aesthetic disruption as it was a social one.

Yes, especially the disjunction between the different materials, which still has a real poignancy. It's quite anarchic.

/

That disjunction of materials is something that appears in your work – the real log in *Log Lady*, or fluffy pompoms stuck onto clay.

It's not something which occurs that often in my work. And in a way it is the actual infrequency which is part of it. They just find their own way in, when it's right. The log for *Log Lady* I found on the way to the studio a few years ago, and it was sitting there for all that time before it became useful.

/

Where do the objects come from that are displayed in the vitrines?

Skips or on the road, sometimes I make them, some of the neon already exists, and some of it I get made. But I don't think the objects are just displayed. The border between the mechanism of display and the actual things being displayed is not clear-cut, to the extent that some of the objects are outside of the display case. The usual hierarchy is not being obeyed, as if the objects and the display cases themselves are exhibiting some kind of delinquency.

/

I know you believe that these objects have a thaumaturgical quality.

Not literally, but I am interested in the way something can be perceived as having a ritual or religious value. With the vitrines it is very much the way the objects are arranged, otherwise they would remain in essence what they are, which is mostly rubbish, bits of fluff and studio detritus.

/

/

/

/

/

/

/

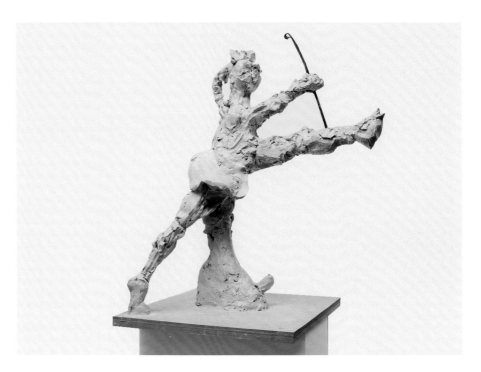

Girl 38, 2003

There are aspects of the vitrines that remind me of Fischli & Weiss, especially their film using everyday objects *Der Lauf Der Dinge*.

There are parts of that film which I think are strangely emotional, and that's what I'm trying to do with the vitrines. It's easily overlooked but I think *I Love the Sound of Breaking Glass* is very melancholic with its sad rays of red and blue light, and all the dust and fragments of glass.
/

Titles remain an important component of your work. Tell me about the title *Dark Passage*.

Sometimes when working out an exhibition I need to find some kind of substantive structure, something that holds the show together. It's an underpinning that never needs to reveal itself, operating at a level even below subtext. In the case of *Dark Passage* it is numerous themes and allegories and formal considerations too, which all coalesce, no single one having predominance over the others.
/
/

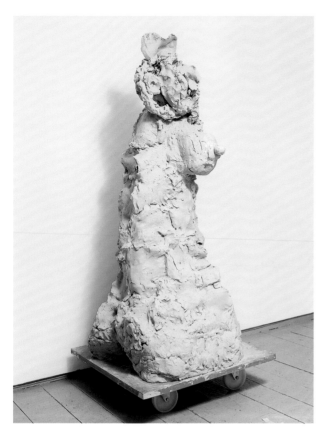

Deutsche Bank, 2002

<u>And some of those themes are?</u>
Well, in a literal way, I was thinking about how to negotiate the actual physical space of the Kunsthalle, which is like a corridor, and taking this linear quality and applying a narrative structure to it.
/

<u>Are you referencing the narrative of the Bogart-Bacall film</u> *Dark Passage*?
No not at all. Although I like the film noir association of the title, and the way that connects back to German Expressionism, and then how that relates to the passage from Weimar decadence to Nazism and the whole genealogy of horror of modern wars.
/
/
/

<u>What narrative are you applying then?</u>

A movement from basic elements in the first room to a central room of dysfunctional cultural aspirations, followed by a descent into mass debauchery, violence and death. And the whole show is pivoted around the central placing of a misshapen bronze cube.

/

<u>How did you come to choose the image for the exhibition poster?</u>

For some reason, for a while, I had the Bruno Bischofberger *Artforum* adverts in my mind. And sausages. I found some great old photographs of sausage shops and sausage factories. But it was a bit of a digression. The image I found of the tunnel was perfect. On the one hand it was a great big dark orifice with this small man in front of it and all the sexual connotations that might imply. On the other it is a great picture of a dark passage in as much as it is possible to illustrate one.

INTERVIEW

Carl Freedman / Rebecca Warren

Kannst Du mir etwas über den Zusammenhang zwischen Freud, The New York Dolls und *Les Demoiselles d'Avignon* erzählen?

Zwischen diesen Bildern gibt es eine seltsame Verwandtschaft, als wären sie unterschiedliche Varianten einundderselben Sache. Insofern ist es vielleicht eine instinktive Reaktion, sie in eine chronologische Ordnung zu bringen, wobei nicht ganz klar ist, was am Anfang steht und was am Ende.

/

Das Freud-Bild und *Les Demoiselles d'Avignon* wurden zum ersten Mal in der Ausstellung *She* kombiniert.

Den Titel *She* hatte ich im Kopf, seit ich den Hammer Horrorfilm gesehen habe. Darin spielt Ursula Andress eine archetypische Schönheit, die nicht altert. Sie ist allmächtig und unberührbar und bringt ihr Missfallen zum Ausdruck, indem sie ihre Opfer in eine Feuergrube fallen lässt. Schliesslich verkehren sich ihre Kräfte jedoch ins Gegenteil und sie verwandelt sich vor den Augen der Männer, deren ultimative Phantasien sie verkörpert, in eine alte Hexe.

/

/

/

/

Wie eng haben sich die Skulpturen in *She* an *Les Demoiselles* angelehnt?

Zunächst wollte ich fünf Figuren, doch als ich weitermachte, wurden es elf, und von da an gerieten sie immer entstellter. Mir gefiel der Gedanke, diese verrückten, hässlichen Skulpturen mit dem Bild von Freud und seinen Kohorten zu kombinieren.

/

In Diskussionen über Deine Arbeit kommt oft der männliche Blick zur Sprache, und dass Du Dich mit Fragen der Geschlechterrollen beschäftigst.

Ich sehe mich nicht auf diesem ausgetretenen Pfad. Meine Position ist bewusst ungesichert. Bei *She* sind die Skulpturen keine Umkehrungen oder Platzhalter. Vielmehr sind das Dinge mit eigener Geschlechtlichkeit.

/

In einer Arbeit beziehst Du Dich auf Helmut Newton und R. Crumb.

Helmut Crumb geht von einem R. Crumb-Cartoon mit dem Titel *Girls, Girls, Girls* aus. Darin verwandelt sich eine Frau immer wieder aufs Neue, einmal wird sie seine Mutter, und am Schluss ist sie eine Möse auf zwei Beinen. Das letzte Bild ist wie monumentale Architektur. Ich wollte etwas Entsprechendes machen, etwas Dreidimensionales.

/

Und wie kam Helmut Newton ins Spiel?

Ich sah Kippenbergers *Helmut Newton für Arme* – Kippenberger, als Bäuerin mit Kopftuch verkleidet, steht in einem billig möblierten Raum. Ich wollte diese bayerische Üppigkeit auf ein Material wie Ton übertragen. Als ich Newtons Buch *White Women* sah, kamen mir die Frauen darin allesamt wie Homunkuli vor. Ein Foto in dem Buch trägt den Titel *In My Apartment*. Es steht offensichtlich in Bezug zu dem Crumb-Cartoon, deshalb habe ich in der anderen Hälfte der Skulptur dieses Gefühl von Geschrumpftheit aufgegriffen.

/

/

/

/

/

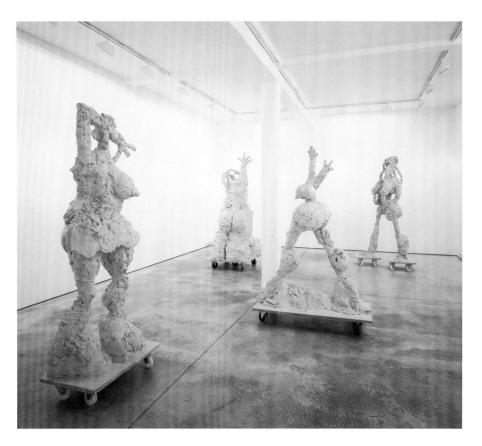

She, 2003
in 7 parts / 7 – teilig, from left to right / von links nach rechts:
Untitled, 2003 / *Homage to R. Crumb, My Father*, 2003 / *No. 6*, 2003 / *South Kent*, 2003

<u>In welchem Verhältnis stehst Du zu den Künstlern, auf die Du Dich beziehst?</u>
Sie beeinflussen mich, und ich lasse das zu. Natürlich spielt da auch ein ganzes Stück Ikonoklasmus mit, das Bedürfnis, den Vater zu beseitigen, die normale Ödipus-Revolte eben. Ich suche einen Weg, mich auszudrücken. Ausdruck ist ein Problem. Ich löse es zum Beispiel, indem ich bereits akzeptierte Ausdrucksformen aufgreife, beispielsweise Auguste Rodin, Willem de Kooning oder Otto Dix.
/
<u>Entziehst Du Dich damit einer eigenen Verantwortung?</u>
Einerseits ja. Andererseits erkenne ich damit aber auch an, was ich den Vorfahren verdanke.
/

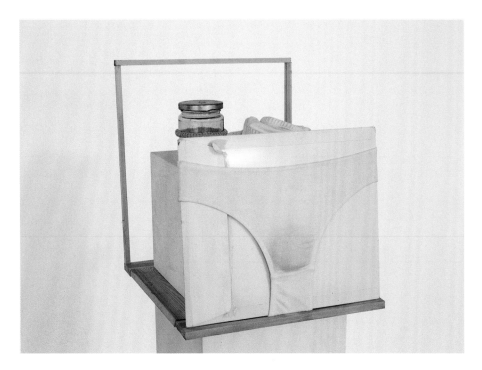

Every Aspect of Bitch Magic, 1996

<u>Es scheint Dir zu gefallen, wenn man Dich nicht als Autorin Deiner Arbeit wahrnimmt, ja Du hast sogar gesagt, es wäre Dir recht, wenn Deine Arbeit wie das Werk eines frustrierten Bastellehrers aus der Provinz aussähe. Mich wundert, dass alle Deine Künstler-Vorbilder männlich sind.</u>

Ja, dadurch kann ich sie ausloten. Ich kann mich auf heiklen Territorien bewegen. Es geht nicht um Didaktik. Es geht darum, das zu untersuchen, was mich anzieht, und herauszufinden, warum.

/

/

/

/

/

/

/

/

/

Was hat Dich an Degas angezogen?

Die kleine Tänzerin. Sie hat eine extreme Wandlung durchgemacht, von ursprünglicher Verschmähtheit zu fast beruhigender Ausstrahlung, von der ursprünglichen Wachsfigur, die Degas sein ganzes Leben lang im Atelier stehen hatte, ohne sie je in Bronze zu giessen, bis zum posthumen Bronzeguss, der nun überall auf der Welt in den Museen steht und uns in diesem Zustand so vertraut ist, dass die ursprüngliche Wachsfigur als abwegig gilt. Es hat die Rezeption keineswegs befördert, dass Degas sie zusammen mit Pastellzeichnungen von Kriminellen ausstellte, alle mit fliehender Stirn und vorstehendem Kinn. Und dann hat er die Skulptur auch noch in eine Vitrine gestellt, was ebenfalls recht ungewöhnlich war und nahelegte, dass es sich bei dem Mädchen um eine besondere Spezies handelte. Das ist ziemlich pervers – einerseits macht er sie ganz bewusst unattraktiv, und dann hängt er doch so sehr an ihr, dass er sie bis zum Tod bei sich behält.

/

/

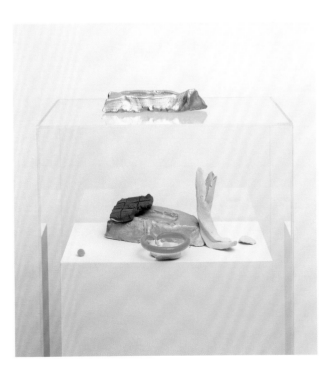

Bitch Magic: The Musical, 2001 - 03

Als sie ausgestellt wurde, war sie sowohl in ästhetischer Hinsicht als auch in gesellschaftlicher eine Irritation.

Ja, vor allem die Verbindung disparater Materialien wirkt auch heute noch seltsam berührend, geradezu anarchisch.

/

Diese Verbindung scheinbar unzusammengehöriger Materialien gibt es ja auch in Deiner Arbeit – der Holzklotz in *Log Lady* oder die flauschigen Bommel auf dem Ton.

Das kommt eigentlich nicht allzu oft in meiner Arbeit vor. Die Seltenheit spielt eine Rolle dabei. Wenn es passt, geraten die Dinge sozusagen von selbst hinein. Den Klotz für *Log Lady* habe ich vor ein paar Jahren auf dem Weg zum Atelier gefunden, und da lag er dann die ganze Zeit herum, bevor er schliesslich zum Einsatz kam.

/

Woher kommen die Objekte, die in den Vitrinen ausgestellt werden?

Aus Bau-Containern oder von der Strasse, manchmal stelle ich sie selber her. Von den Neon-Objekten habe ich einige so vorgefunden, und manche lasse ich fertigen. Aber ich sehe es nicht so, dass die Objekte ausgestellt werden. Die Grenze zwischen dem Ausstellungs-Mechanismus und den eigentlichen Gegenständen, die da zu sehen sind, ist fliessend, manche der Objekte befinden sich sogar ausserhalb der Vitrine. Die übliche Hierarchie wird nicht eingehalten, so als demonstrierten die Objekte und die Vitrinen selbst eine gewisse Abtrünnigkeit.

/

Ich weiss, dass diese Objekte in Deinen Augen eine magische Qualität haben.

Nicht im wörtlichen Sinn, aber mich interessiert, wie es dazu kommt, dass manchen Dingen eine rituelle oder religiöse Bedeutung zugesprochen wird. Bei den Vitrinen geht es darum, wie die Objekte arrangiert sind, denn ansonsten blieben sie einfach das, was sie sind, also meistens Reste und Abfall aus dem Atelier.

/

/

/

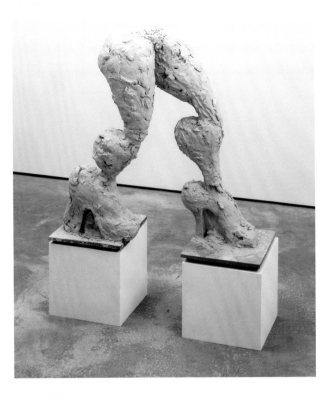

Crocioni, 2000

Ich finde den Film streckenweise seltsam emotional, und genau das versuche ich mit meinen Vitrinen auch. Es wird zwar leicht übersehen, aber ich finde *I Love the Sound of Breaking Glass* ist sehr melancholisch mit seinen traurigen Strahlen von rotem und blauem Licht, mit all dem Staub und den Glasscherben.

/

/

/

/

/

/

Die Titel spielen in Deinem Werk eine wichtige Rolle. Erzähl mir etwas über den Titel Dark Passage.

Wenn ich eine Ausstellung entwerfe, suche ich manchmal nach einer inneren Struktur, etwas, das die Show zusammenhält. Es ist ein Fundament, das man gar nicht bemerken muss, weil es auf einer Ebene unterhalb des Subtexts wirkt. Bei *Dark Passage* ist es das Zusammenspiel aus zahlreichen Themen, Allegorien und formalen Gesichtspunkten, wobei keiner davon Vorrang vor den anderen hat.

/

Was wären das beispielsweise für Themen?

Ich habe darüber nachgedacht, wie ich den linearen Charakter des tatsächlichen, physischen Raums der Kunsthalle, der ja einem Korridor gleicht, mit einer Erzählstruktur verknüpfen kann.

/

Beziehst Du Dich auf die Geschichte des Films Dark Passage *mit Humphrey Bogart und Lauren Bacall?*

Nein, überhaupt nicht. Allerdings mag ich den Anklang an den Film Noir im Titel. Ausserdem mag ich die Verbindung zum Deutschen Expressionismus und wiederum dessen Bezug zum Übergang von der Weimarer Dekadenz zum Nazismus sowie zur Entstehungsgeschichte des Horrors der modernen Kriege.

/

Um welche Erzählung geht es denn dann?

Um eine Bewegung von fundamentalen Dingen im ersten Raum zu einem zentralen Raum der fehlgeschlagenen Kultur-Bestrebungen, gefolgt vom Absturz in Massenhysterie, Gewalt und Tod. Und die ganze Ausstellung ist angeordnet rund um einen unförmigen Bronze-Kubus in der Mitte.

/

/

/

/

/

/

/

<u>Wie bist Du auf das Bild für das Ausstellungs-Plakat gekommen?</u>
Aus irgendeinem Grund hatte ich eine Zeitlang die Artforum-Anzeigen von Bruno Bischofberger im Kopf. Und Würste. Ich stiess auf ein paar grossartige alte Fotos von Metzgereien und Wurst-Fabriken. Aber es war eine Art Umweg. Das Bild, das ich von dem Tunnel fand, war perfekt. Einerseits hat man da die grosse dunkle Öffnung mit diesem kleinen Menschen im Vordergrund und all die möglichen sexuellen Konnotationen. Andererseits ist es einfach nur das wunderbare Bild von einer dunklen Passage, die es zugleich auch illustriert.

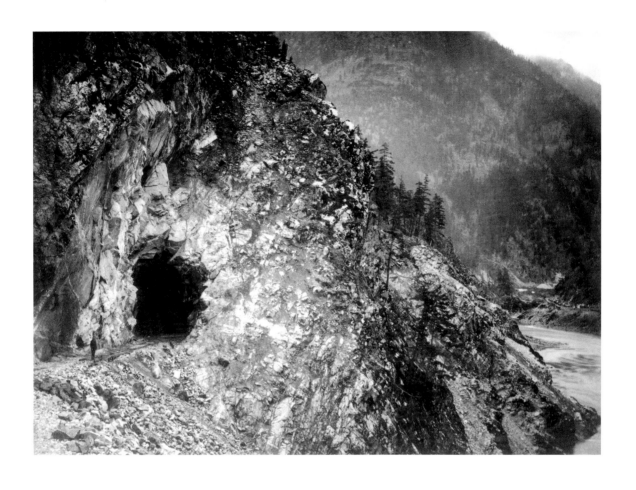

DARK PASSAGE

Gregorio Magnani

"The world is filled to suffocating. Man has placed his token on every stone. Every word, every image, is leased and mortgaged. We know that a picture is but a space in which a variety of images, none of them original, blend and clash. A Picture is a tissue of quotations drawn from the innumerable centres of culture. Similar to those eternal copyists Bouvard and Pécuchet, we indicate the profound ridiculousness that is precisely the truth of painting. We can only imitate a gesture that is always anterior, never original. Succeeding the painter, the plagiarist no longer bears within him passions, humours, feelings, impressions, but rather this immense encyclopaedia from which he draws. The viewer is a tablet on which all the quotations that make up a painting are inscribed without any of them being lost. A painting's meaning lies not in its origin, but in its destination. The birth of the viewer must be at the cost of the painter."

Sherrie Levine[1]

/

"Ah! Giotto, don't prevent me from seeing Paris, and you Paris, let me see Giotto."

Edgard Degas[2]

/

A foreboding creature stands guard at the entrance of *Dark Passage*. Definitely female – her anatomy is made up almost exclusively by tits and ass – she carries on her breasts a large log of wood whose branches have been chopped off. We are not sure if this is a weapon or an offering. As she appears to rise out of still recognisable clay bricks barely shaped by the artist's hand and left to spill over the rough wheeled pedestal, *Log Lady* (2004) is both a figure of worship and at the same time fragile, almost pitiful. Standing proud, she flaunts her vast endowments and her powerful presence, but there is a suggestion of something flawed in the brittle and cracked appearance of the unfired clay of which she's made. We realise that she's legless, and armless. Most significantly, she's headless and therefore, we may presume, brainless.

/

As one keeps looking, a set of associations comes to mind. Firstly with David Lynch's *Twin Peaks*, with the woman whose log knew everything but would not tell. One feels this is so inescapable that it must lead somewhere, if only perhaps to a course in which meanings coexist and multiply, a world of lush excess and proliferation, whose logic is inclusive rather than limiting. Here, being Mrs. X from *Twin Peaks* does not exclude the sculpture's reference to Cerberus, the guardian of the underworld. Nor her role as sexual goddess, of abject masturbatory fantasy, or her lofty proximity to any number of mutilated classical Venuses.

/

Log Lady shares the beginning of *Dark Passage* with *I Love the Sound of Breaking Glass* (2004) and *Reingold* (2004), two vitrine pieces. Among Warren's most reticent works, *I Love the Sound of Breaking Glass* consists of three elongated MDF cases hung on the wall at eye level. Though each has its front covered by a sheet of Perspex, these appear to be the wrong size for the opening they are supposedly sealing and are coarsely screwed to the case so that a large gap is left open. The Perspex is also extremely dusty. Various bits of wood, glass shards, a few twigs, some more unpainted MDF and other assorted detritus have been placed on top of the vitrines, just at the edge of visibility. Strangely, what's inside and has apparently been deemed worthy of preserving is

not that different. Two small squiggles in red and blue neon may be crude approximations of male and female sexual organs, and the gilded wedge inside one of the boxes refers – or perhaps even replicates – Duchamp's *Wedge of Chastity* (1954–1963) possibly via Lynda Benglis 1980s gilded sculptures. There are also lots of fluffy things, some vaguely anthropomorphic things, some proper trash, some rather repulsive cast off bits of dried clay on a string not dissimilar to petrified washing machine fluff, and quite a lot of dirt. Not pretty, romantic dirt, just dirt.

/

Reingold (2004) is a freestanding, smaller vitrine. It contains more assorted bits; something which may be the rough cast of an armpit or a slightly melted bar of Swiss chocolate, a small yellow ball, more glass shards, some bits of felt. Again a small lump of clay has been dropped on top of the Perspex case and allowed to solidify there. *Reingold* is surprisingly clean, but we soon discover that this is an attempt to hide the fact that one of the sides of its Plexi top is altogether missing. In its stead a small bit of MDF has been nailed to the pedestal so that it sticks up into the virtual space defined by the transparent cube.

/

There is a clear sexual tension involved in the relationship among the three horizontal vitrines and the single vertical one, but it is a sort of comedy tension, like that of a joke which relies for its punch line on stating the obvious. One gets the feeling Warren may have done more than her share of thinking about questions of gender, representation and self-representation, but also that she is extremely careful and extremely wary that the work may not be defined as that. Indeed it appears that there are many things the work is careful not to be.

/

I Love the Sound of Breaking Glass and *Reingold* make reference to art history, but don't give you enough to construct an argument. They employ bits and fragments from the artist's studio, but most definitely do not allow any kitchen sink lyricism. They seem to construct a portrait of the artist not as you'd expect through the exquisite achievements of her craft but through its most debased leftovers.

/

43

Vitrines always seem to refer to Joseph Beuys. Here there are bits of felt and twigs pointing that way, but it doesn't go anywhere – at least definitely not towards the German's earnest romanticism. Yet, as with an earlier similar work titled *Every Aspect of Bitch Magic* (1996),[3] Warren's vitrines seem indeed to be referencing some obscure alchemical or magical ritual whose purpose is now lost. In this case, the proximity to *Log Lady* suggests that the ritual may be an initiation into the show's Dark Passage. *I Love the Sound of Breaking Glass* and *Reingold* fail to perform as vitrines. They do not manage to significantly separate and distinguish between what's inside and what's outside. Instead they suggest a continuous flux of things moving in and out of the boxes, a permanent readdressing of interests, responses and relevancies.
/
What is singled out, then, appears to be not so much the individual objects contained in or excluded from these anti-vitrines, but a particular relationship of which the vitrines themselves are an element.
/
"Pathetic assemblage doesn't try to poeticise its grungy materials, it has no interest in redeeming the unworthy, discovering the exotic or heroic in everyday life" wrote Ralph Rugoff in his *Just Pathetic* catalogue of 1990.[4] To be pathetic, he argues, is to haplessly fall short of the idealised norm, to fail to conform because of a lack of mastery and self-control; to be laughable. Pathetic art has failure at its core. It substitutes ineptitude for mastery and it excludes itself from the discourse of winning. For Rugoff working in Los Angeles to define a specific West Coast aesthetic, the prime exemplar of pathetic art was Mike Kelley; from a European position, Martin Kippenberger would have been equally appropriate.
/
Importantly for us here pathetic art is also wilfully opposed to the heroic stance taken by modern art of the last century. Alternatively seeing itself as transgressive or transcendent, modern art has always claimed a position of power. Even if its social and spiritual power may appear lost, art has always at least claimed absolute control over its own definition and language. Accordingly, whether addressing sexuality,

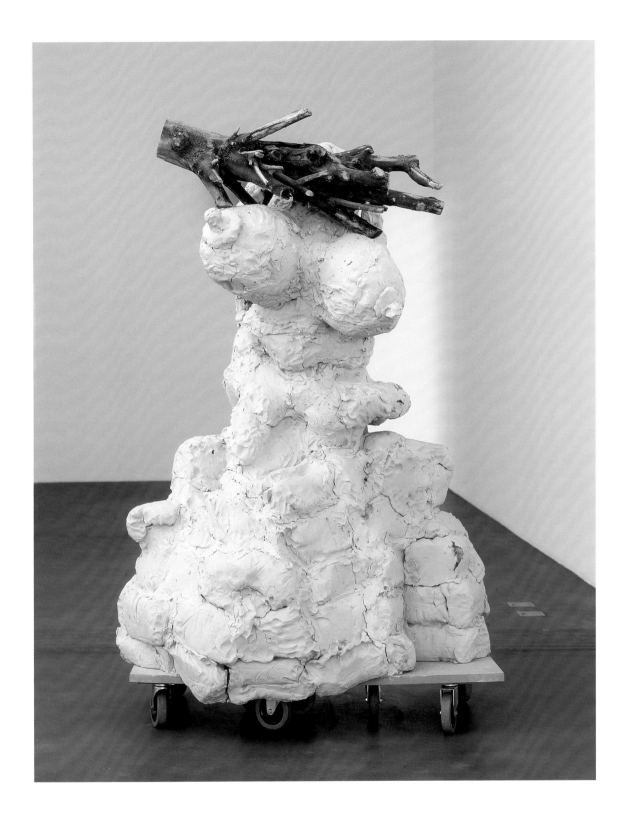

Log Lady, 2003

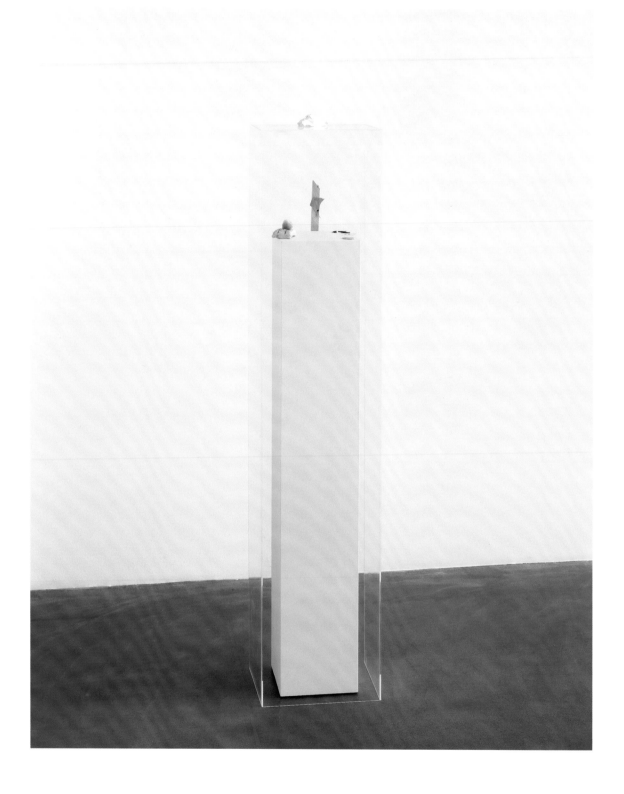

Reingold, 2004

the grand ahistorical narratives of death and love, or autobiography, the generation of British artists who preceded Warren on the international stage have always seen themselves as acting from a position of absolute mastery of their chosen subject and language (see for example Sarah Lucas' often quoted statement "art is something I have at the tips of my fingers").

/

Conversely, a suggestion of failure and inability to perform is essential to Rebecca Warren's work. Her sculptures crack and spill over apparently misjudged pedestals, her vitrines are screwed together in the clumsiest of ways, full of dust and closed by dirty sheets of Plexiglas which don't quite match the openings they are meant to seal. The objects she casts in bronze appear often too banal to be worthy of this costly material while unfired clay brings a suggestion of the unfinished and of the unstable.

/

A sculpture stands out in the second *Dark Passage* room. Portentously titled *The Light of the World* (2004) it is presented on a low coloured pedestal. Though actually made of clay, it is coloured to look like bronze. Approximately one metre high, it is in the shape of a roughly modelled, vastly enlarged goblet. Both the choice of material and the shape suggest an association with some sacred purpose such as the Holy Grail or a church chalice. However the stem of the goblet bends under the uneven balance of its top, and the whole seems on the point of collapse. The sculpture is emphatically hand-made and emphatically referential to the grand signature modelling of 19th century bronze sculpture from Rodin to Rosso. Walking around it one is therefore shocked to discover that a small fluffy ball, more or less the same colour as the sculpture and therefore barely visible, has been attached to the side of the vessel. It seems clear that Warren is – and wants us to be – ambiguous about the weighty symbolism of her own sculpture, which now seems suddenly the perversely enlarged version of a child's plasticine sculpture.

/

Unfired clay, hands-on modelling, fluffy pompoms, sexual themes and excessive sexual attributes; art historical references vernacularised and

remodelled as small figurines: the figure that is invoked seems from this perspective to be that of the hobbyist.

/

Discussing his *Birdhouse for a Bird That Is Near and a Bird That Is Far* (1979), Mike Kelley said his intention was to "release some deviation from the unconsciously normative notion of the hobbyist".[5] Claiming an historical and emotional position excluded from the discourse of winning, Kelley questioned the universalistic assumptions of minimalism. For Rugoff, writing in 1990, the figure of the position of the loser could be invoked against the triumphant and triumphalist commodification of art in the late 1980s. For Warren, not dissimilarly to other artists such Hesse, Trockel, Genzken, and Jan Ader, an engagement with the notion of failure is a way to articulate difference, to intervene in the discourse of winning that is western art in one's own terms.

/

The only bronze piece in the show is nearby. It is a small hand-modelled cube mounted on wheels, whose apparent density sets it apart from the other works. Installed more or less in the centre of the room, it functions visually as a pivotal point around which the whole of *Dark Passage* rotates. Referencing at once gold bullion and minimalist sculpture, it was originally titled *Credit Swis* (sic), suggesting an association between the show's title and the specific history of Swiss banking (Warren explains the peculiar spelling of Swiss as "not wanting to mention the SS"). A historically specific narrative is further enforced by *Dark Passage* (2004), a large unfired clay sculpture presented nearby. This is a fantastically excessive and fantastically humorous work. Once again it's a female figure, once again she's headless. Her bosoms sprout a bundle of tentacles, which in Warren's vocabulary often stands for the figure's diminished intellectual capacities, something between a web of exposed nerves, a courtesan's coiffure, and an empty decorative flourish. Marching forward with inane determination this creature actually enacts that strategy of multiple readings which is essential to Warren's work. The benign cartoon-like face and long stretched neck of the animal that this large breasted lady appears at first to be riding, turn out also be a third extended leg shod in one of

Warren's signature Minnie Mouse pumps, and unmistakably goose stepping.

/

Close to the wall in the middle room of the show stands a double sculpture titled *The Twins* (2004). The two figures are clearly derived from Degas' *The Little Dancer of Fourteen* (1880–1881), now at the Tate Gallery in London. Warren selected it as one of the five works of art she would choose to own in a recent Frieze Magazine survey. On that occasion, she remarked that she would have loved to be able to put it in front of Martin Kippenberger's *For the Life of Me I Can't See a Swastika in This Painting* (1984). If this is one of Warren's works most obviously concerned with sculptural tradition, and one whose precedent is most immediately identifiable, *The Twins* is unsurprisingly also one in which Warren's ambiguity about that tradition is most clearly expressed.

/

The Little Dancer of Fourteen was the only sculpture exhibited by Degas during his lifetime. Shown at the Impressionist exhibition of 1881 in Paris, it created a huge sensation, prompting the critic J. K. Huysmans to write: "The frightful realism of this statuette evidently makes people uncomfortable: all our ideas on sculpture, on those cold, inanimate white objects, on those memorable imitations, copied and recopied for centuries, are upset. The fact is that, with a single blow, M. Degas has overthrown the traditions of sculpture".[6] Degas' sculpture, with its real fabric bodice, shoes and ribbon holding the hair, does indeed still appear as an extraordinary work of realist art, an absolutely individualised and absolutely immediate representation of a particular and unique subject. Warren has installed her twins on a high pale pink pedestal and encased them in a double Plexiglas box just barely wide enough for them. This is further divided in the middle by another sheet of Plexiglas so that each twin is crammed in its own little transparent box and isolated from its companion. Though the two figures are very similar, they are not identical (Warren says that she originally thought about making them identical but than realised this was not necessary). One is reminded of Robert Rauschenberg's identical Expressionist paintings *Factum 1* and *Factum 2* (1957) of Sturtevant 'doing' Warhol,

of Haim Steinbach's displays, of Francis Bacon's boxes. One is also reminded of a shooting gallery, a display of giant dolls as one may find in a 1940s film noir.

/

Significantly in relation to Warren's adaptation, Degas' sculpture is also in many ways a portrait of innocence: "a female who is neither quite yet a woman nor quite fallen"[7] – from an artist and a period obsessed with the figures of the prostitute and the courtesan. Speaking about his work Degas said, "the nude has always been represented in poses which presuppose an audience, but these women of mine are honest simple folk, unconcerned by any other interest than those involved in their physical condition. Here is another, she is washing her feet. It is as if you looked through a keyhole."[8] Warren has endowed her girls with innocent ribbons, vast calves, a pair of platform shoes, and a tiny apron of the type still sometimes found on the waitresses of particularly unpleasant drinking establishments, especially in Bavaria and Switzerland. In a characteristic Warren gesture, these two vastly bosomed housewives ready to perform in an erotic peep show have been installed facing the wall to expose their bottoms. Literally turning their back to the viewer, Warren's twins are, in true post-feminist fashion, fully enjoying their status as objects of the gaze and are ready to kick open the door and reveal Degas' embarrassing erection.

/

The appearance of frantic creativity, "art historical capriciousness"[9] and stylised madness dominate the group of statuettes presented in the exhibition's final room. Installed on tall white or pale pink pedestals, these small sculptures mix glazed and unglazed clay, splashes of generally tenuous colours with dabs of bright cadmium and a few gold highlights. They mostly appear to represent various forms of coupling. This is clearly a room to wander about in, a set of works to look at and then return to. Some of the figurines are very much in the round, to be seen from 360 degrees; others clearly have a back. Some reference previous art works, in particular Otto Dix's. So the punctured legs of *Hundemeister* (2004) can be traced back to the central panel of Otto Dix's *Der Krieg* (1929–1932) perhaps via Georg Baselitz, and

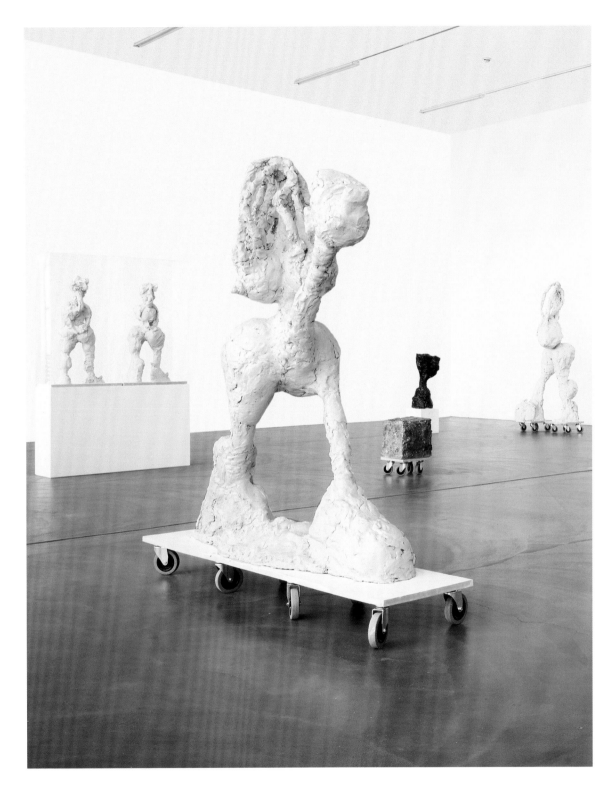

Installation view / Ausstellungsansicht

Dark Passage, Kunsthalle Zürich

from left to right / von links nach rechts:

The Twins, 2004 / *Dark Passage*, 2004 / *Cube*, 2003 / *The Light of the World*, 2004 / *Teacher (M.B.)*, 2003

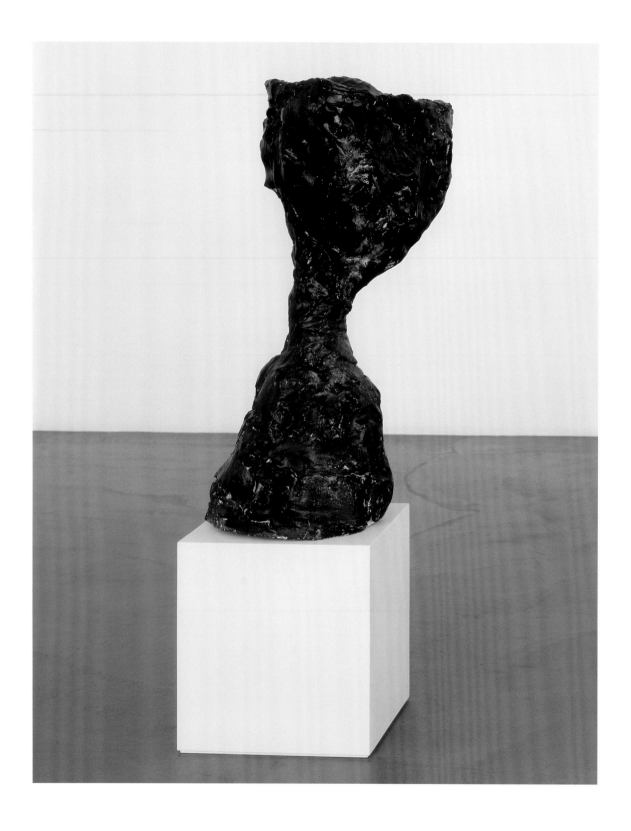

The Light of the World, 2004

Lustmord III (2004) derives from Dix's incredibly gruesome painting and etching of the same title (both 1922). *Älteres Liebespaar* (2004) is a three-dimensional rendering of Dix's *Ungleiches Liebespaar* painting of 1925. With Warren, however, the lovers have become equal, and the extravagantly coifed lady (one of her arms amputated and bleeding, but still unquestionably in control of the situation) proudly straddles a broad shouldered green hunk, rather than the decrepit old man depicted by Dix. Other groupings hover just at the edge of recognisable representation, bits of anatomy seeming to emerge and disappear in otherwise undecipherable agglomerations. Further disembodied anatomical bits, such as gilded vaginas, penises, breasts, feet may also pop up from the non-narrative, otherwise undefined terrain at the periphery of the central scene. Viewing the work thus becomes a complex and significant activity, a conscious act of research. All the pedestals are the same size and height except for the two pink ones, which are higher. Some of the sculptures overspill their plinths and seem in permanent danger of crashing to the floor, like the figure of a man ejaculating on a woman face – *The Pearls of Switzerland* (2004) – or the mysterious green, brown, and pink blob where I thought I saw the face of a horse. Often the sexual acts, in which everybody is engaged, appear to take on sinister tones. Smatterings of blood often mark the ladies' crotches, the mounds of bodies seem closer to renderings of Rodin's *Gates of Hell* than to 1970s visions of free love. There is also a lovely little white sculpture titled *O.D.* (2004), while armchairs incongruously patterned in gingham support vast gilded ladies exhibiting themselves, and Dix's old lovers lending a note of bourgeoisie gloom to the whole installation.

/

As one looks back at the whole exhibition and at the complex web of interests, detours, references and double takes, one is reminded of Jennifer Higgie's comment on *Croccioni* (2000), Warren's take on Umberto Boccioni's *Unique Forms of Continuity in Space* (1913): "As with Warren's best sculptures it makes tangible her struggle with process and precedence, with irregularity and exploration; with looking and looking again, and then changing your mind just when you think

you've got it."[10] Notions of process and language are, I think, central to Warren's art.

/

According to Freud, the history of the patient is not in some original truth that emerges behind the chain of association, but in the process itself. This process is quickly identified with language producing meaning in the shifting relationship between terms. There is a sense in which Warren implicates herself in the work as a cipher, and as an element in the chain of equal and mutually interdependent signifiers; she appears to be performing a role in a narrative rather than merely assuming the role of its author. Emphatically hand-modelled and emphatically the result of a struggle, her sculptures seem both the outcome of a process of self-analysis and self-expression and a representation of that process. They seem both to enjoy the pleasures of undiluted individuality and to be keenly aware of its slightly comical nature. Embracing mistranslations and partial misunderstandings, Warren uses a wealth of intended references and associations to encourage a proliferation of unintended readings. Insisting at once on manuality and failure, on the continuously displayed oscillation between the awkward and the masterful, she weaves in and out of the expected narrative. History, gender, precedence, individuality self-expression, mastery all appear both as part of the work and as ciphers of their own history, elements whose interconnection allows the real pleasure of making art and of one's love for one's precedents.

/

Finally one must remember that a certain amount of wilful misleading is often part of Warren's practice. Recently she has called a show *She* and presented it as inspired by the enormously dull Hammer movie starring Ursula Andress of the same title; or genially, accompanied an exhibition at Modern Art in London with an intoxicated hyperbolic press release[11] distributed only in German. Its final sentence translates approximately as: "We are here not concerned with beerkeller mentality, rather the hallucinatory social intercourse and inversions arising when Jägermeister feeds the twisted pair of will and libido".

1 Levine's statement begins with a quote
 from Franz Marc and ends with a variation
 on the conclusion of Roland Barthes' *The
 Death of the Author*. Reprinted in Harrison,
 Charles, Wood, Paul (ed.) *Art and Theory
 1900–1990*, Blackwell, Oxford/
 Cambridge 1993.

2 From "Notebook 22", Richard Kendall
 (ed.) *Degas by Himself. Drawings, prints,
 paintings, writings*, Time Warner Books,
 London 2004, p. 39.

3 These vitrines also revive early experiments
 within her own practice, sometimes
 conducted in collaboration with Fergal
 Stapleton, in which the work was made in
 the gallery and with the reality available
 materials.

4 Rugoff, Ralph, *Just Pathetic*, Rosamund
 Felsen Gallery, Los Angeles 1990.

5 Elisabeth Sussman, "Introduction", *Mike
 Kelley: Catholic Taste*, Whitney Museum
 of American Art, New York 1994, p. 20.

6 Linda Nochlin, *Realism*, Penguin Books,
 London: 1990, p. 269.

7 Ibid, p. 206.

8 "Edgar Degas to George Moore", Honour
 and Fleming, *The Visual Art: A History*,
 Macmillan Publishers, Basingstoke,
 Hampshire 1982, p. 551.

9 Jennifer Higgie, "Under the Influence",
 Frieze, January/February 2003, p. 67.

10 Ibid.

11 Carl Freedman, "Fleischvater", press release,
 Modern Art, London: November/
 December 2002.

DARK PASSAGE

Gregorio Magnani

„Die Welt ist zum Ersticken voll. Auf jeden Stein hat der Mensch sein Pfand gelegt. Jedes Wort, jedes Bild ist gepachtet und belehnt. Wir wissen, dass ein Bild nur ein Raum ist, in dem die verschiedensten Bilder – keines von ihnen ein Original – aufeinanderprallen und verschmelzen. Ein Bild ist ein Gewebe aus Zitaten, die aus den zahllosen Zentren der Kultur stammen. Gleich den ewigen Kopisten Bouvard und Pécuchet bringen wir jene extreme Lächerlichkeit zum Ausdruck, die die Wahrheit des Malens ausmacht. Wir können nur eine Geste imitieren, die immer vorangeht und nie ursprünglich ist. Der Nachahmer, der in die Fussstapfen des Malers tritt, spürt keine Leidenschaften, Launen, Gefühle, Eindrücke mehr, sondern trägt innerlich eine dicke Enzyklopädie mit sich, die er konsultiert. Der Betrachter ist eine Tafel, auf der alle Zitate eingraviert werden, aus denen sich ein Gemälde zusammensetzt, ohne dass auch nur ein einziges verloren geht. Die Bedeutung eines Bildes liegt nicht in seinem Ursprung, sondern in seiner Bestimmung. Der Betrachter verdankt seine Existenz dem Maler."

Sherrie Levine[1]

/

„Ah Giotto, halte mich nicht davon ab, Paris zu sehen, und du, Paris, lass mich Giotto sehen!"

Edgar Degas[2]

/

Ein unheilvolles Wesen hält beim Eingang zu *Dark Passage* Wache: Es ist eindeutig weiblich – seine Anatomie besteht nahezu ausschliesslich aus Busen und Hintern. Auf den Brüsten trägt es einen kleinen Baumstamm mit abgehackten Ästen. Man weiss nicht genau, ob es sich dabei um eine Waffe oder eine Opfergabe handelt. Die *Log Lady* (2004) scheint sich aus noch immer als solche erkennbaren, von der Hand der Künstlerin nur unwesentlich modellierten Lehmziegeln zu erheben, die sich über den rohen Sockel auf Rädern ergiessen. Sie ist ein Gegenstand der Verehrung und wirkt dennoch zerbrechlich, fast Mitleid erregend. Stolz steht sie da und präsentiert ihre üppigen Kurven und ihre starke Ausstrahlung, doch der brüchigen, rissigen Oberfläche des ungebrannten Tons, aus dem sie geformt ist, haftet etwas Unzulängliches an. Uns wird bewusst, dass sie weder Arme noch Beine besitzt. Mehr noch, sie hat auch keinen Kopf und daher, so ist anzunehmen, auch kein Hirn.

/

Bei längerem Betrachten stellen sich eine Reihe von Assoziationen ein. Zuerst kommt einem David Lynchs *Twin Peaks* in den Sinn, die Frau, deren Baumstamm alles wusste, aber nichts verraten wollte. Man spürt eine gewisse Unausweichlichkeit, fühlt, dass dies irgendwo hinführen muss, und wenn vielleicht nur auf einen Weg, auf dem Bedeutungen koexistieren und sich vervielfachen, zu einer Welt des üppigen Überflusses und der Vermehrung, deren Logik nicht begrenzend, sondern einschliessend ist. Hier schliesst die Verkörperung der Mrs. X aus *Twin Peaks* eine Anspielung auf Zerberus, den Wächter der Unterwelt, nicht aus. Genauso wenig wie die Rolle der Skulptur als Sexgöttin und Gegenstand armseliger Masturbationsfantasien oder ihre erhabene Nähe zu unzähligen verstümmelten klassischen Venusstatuen.

/

Die *Log Lady* teilt sich den Eingangsbereich von *Dark Passage* mit zwei Vitrinenarbeiten, *I Love the Sound of Breaking Glass* (2004) und *Reingold* (2004). *I Love the Sound of Breaking Glass* gehört zu Warrens schlichtesten Werken. Es besteht aus drei länglichen MDF-Gehäusen, die auf Augenhöhe an der Wand hängen. Alle drei sind vorne mit Plexiglasplatten abgedeckt, doch diese sind offenbar zu knapp bemessen und

eher behelfsmässig an die Gehäuse geschraubt, so dass da eine grosse Lücke klafft. Ausserdem ist das Plexiglas sehr matt. Auf den Vitrinen liegen, gerade noch sichtbar, verschiedene Holzstücke, Glasscherben, ein paar Zweige, unbemalte MDF-Bruchstücke und weiterer Unrat. Erstaunlicherweise ist der Inhalt der Vitrinen, der offensichtlich für ausstellungswürdig befunden wurde, nicht besonders anders. Zwei kleine rote und blaue Neon-Kringel sind möglicherweise grobe Nachahmungen des männlichen und des weiblichen Geschlechtsorgans, und der vergoldete Keil in einer der Vitrinen ist ein Verweis auf – oder gar eine Nachbildung von – Duchamps *Keuschheitskeil* (1954–63), vielleicht mit einer Anspielung auf Lynda Benglis vergoldete Skulpturen der 80er Jahre. Ausserdem gibt es da viele flauschige Dinge, etliche irgendwie anthropomorphe Gegenstände, einigen echten Müll, ein paar eher abstossende getrocknete Tonstücke an einer Schnur, die an versteinerte Waschmaschinenflusen erinnern, und ziemlich viel Dreck. Kein hübscher, romantischer Dreck, einfach Dreck.

/

Reingold (2004) ist eine frei stehende kleinere Vitrine. Sie enthält ebenfalls ein Sammelsurium von Gegenständen: etwas, was aussieht wie der rohe Abguss einer Achselhöhle oder eine leicht geschmolzene Tafel Schweizer Schokolade, eine kleine gelbe Kugel, weitere Glasscherben, ein paar Filzstücke. Auch hier ist ein kleiner Tonklumpen oben auf dem Plexiglasgehäuse gelandet und dort eingetrocknet. *Reingold* ist überraschend sauber, doch wir merken bald, dass dadurch verborgen werden soll, dass die eine Seite der Plexiglasabdeckung ganz fehlt. Stattdessen wurde ein kleines Stück MDF so an den Sockel genagelt, dass es in den durch den transparenten Quader gebildeten virtuellen Raum ragt.

/

In der Beziehung zwischen den drei horizontalen Vitrinen und der einzelnen vertikalen ist eindeutig eine sexuelle Spannung spürbar, doch sie ist eher komischer Natur, wie bei einem Witz, dessen Pointe auf der Feststellung längst bekannter Tatsachen aufbaut. Man gewinnt den Eindruck, Warren habe ausführlicher als nötig über Geschlechterfragen, Darstellung und Selbstdarstellung nachgedacht, sei aber auch sehr

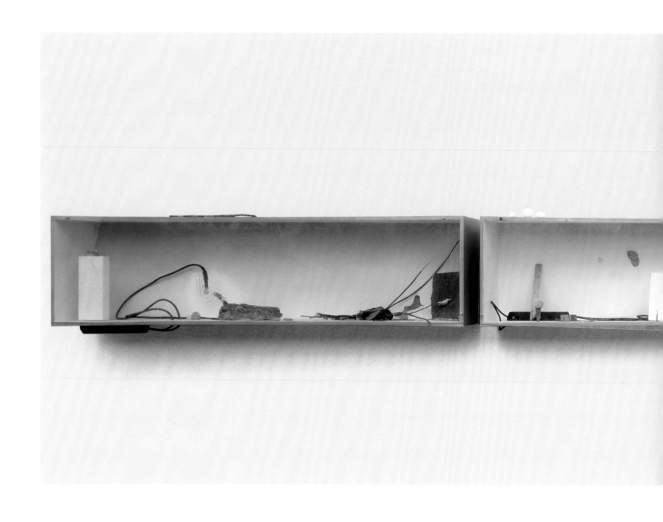

I Love the Sound of Breaking Glass, 2004

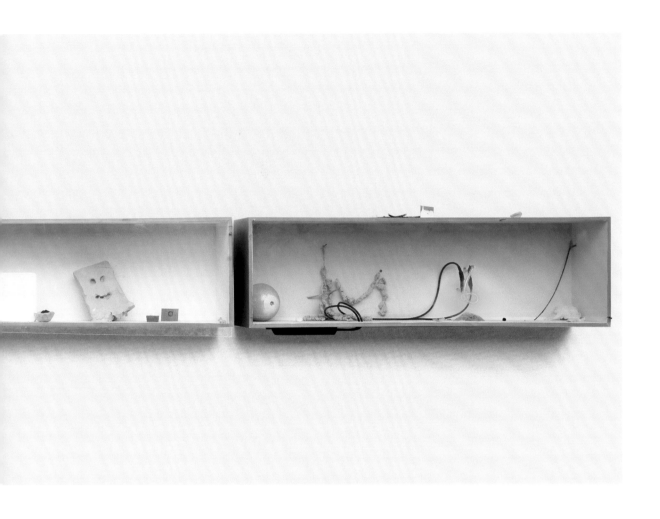

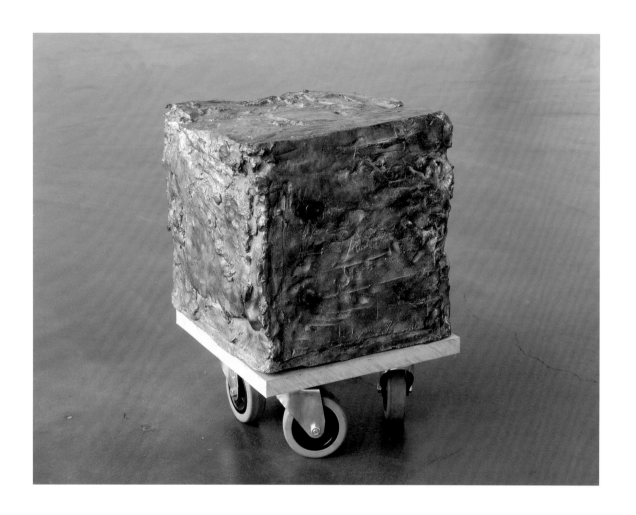

Cube, 2003

darauf bedacht, dass das Werk nicht in dieser Weise definiert wird. Es scheint tatsächlich vieles zu geben, was das Werk versucht nicht zu sein.
/
I Love the Sound of Breaking Glass und *Reingold* verweisen auf die Kunstgeschichte, geben aber zu wenig Anhaltspunkte, um daraus ein Argument abzuleiten. Sie verwenden allerlei Gegenstände aus dem Künstleratelier, lassen aber mit Bestimmtheit keinerlei neonaturalistische Gefühlsduselei zu. Sie scheinen ein Porträt der Künstlerin zu zeichnen, das nicht wie erwartet die meisterlichen Hervorbringungen ihres Handwerks in den Vordergrund rückt, sondern dessen schäbigste Überreste.
/
Vitrinen scheinen immer auf Joseph Beuys zu verweisen. Hier deuten auch Filzstücke und Zweige in diese Richtung, doch das Ganze läuft ins Leere – auf jeden Fall nicht in Richtung der ernsten Romantik des deutschen Künstlers. Allerdings scheinen Warrens Vitrinen genau wie ein ähnliches früheres Werk mit dem Titel *Every Aspect of Bitch Magic* (1996)[3] tatsächlich auf irgendein obskures alchemistisches oder magisches Ritual anzuspielen, dessen Sinn heute nicht mehr erkennbar ist. Hier lässt die Nähe zur *Log Lady* darauf schliessen, dass das Ritual eine Initiation in die dunklen Gefilde – die Dark Passage – der Ausstellung ist. *I Love the Sound of Breaking Glass* und *Reingold* erfüllen ihre Aufgabe als Vitrinen nicht. Es gelingt ihnen nicht, innen und aussen klar voneinander zu trennen und zu unterscheiden. Stattdessen legen sie nahe, dass sich die Dinge in- und ausserhalb der Schaukästen in einem ständigen Fluss befinden, und Interessen, Reaktionen und Bedeutungen fortwährend neu verhandelt werden. Die Betonung liegt daher weniger auf den einzelnen Gegenständen, die in- oder ausserhalb dieser Anti-Vitrinen platziert sind, sondern auf einer besonderen Beziehung, von der auch die Vitrinen selbst ein Teil sind.
/
„Die armselige Assemblage versucht nicht, ihren schmuddeligen Materialien Poesie zu verleihen, sie hat kein Interesse daran, das Minderwertige zu erhöhen und das Exotische oder Heroische im Alltag zu entdecken", schrieb Ralph Rugoff im 1990 erschienenen *Just Pathetic*-Katalog[4]. Armseligkeit bedeutet, so argumentiert er, hinter der

idealisierten Norm zurückzubleiben, ihr wegen eines Mangels an Können und Selbstdisziplin nicht zu entsprechen, lächerlich zu sein. Bei der armseligen Kunst ist das Scheitern ein zentrales Element. Sie ersetzt Können durch Stümperhaftigkeit und nimmt sich aus dem Gewinndiskurs aus. Für Rugoff, der in Los Angeles arbeitete, um eine spezifische Westküstenästhetik zu definieren, war Mike Kelleys Schaffen das beste Beispiel für armselige Kunst; aus europäischer Sicht wären wohl Martin Kippenbergers Arbeiten zu nennen.

/

Von Bedeutung ist in diesem Zusammenhang, dass sich die armselige Kunst bewusst der heroischen Haltung der modernen Kunst des letzten Jahrhunderts widersetzt. Die moderne Kunst, die sich wahlweise als transgressiv oder transzendent wahrnahm, hat für sich stets eine Machtposition in Anspruch genommen. Auch wenn die Kunst offenbar ihre gesellschaftliche und geistige Macht verloren hat, hat sie zumindest immer die uneingeschränkte Kontrolle über ihre eigene Definition und Sprache beansprucht. Entsprechend war die Generation britischer Künstler, die Warren auf der internationalen Bühne voranging, ob sie sich nun mit Sexualität, den grossen zeitlosen Themen von Tod und Liebe oder mit Autobiografischem auseinander setzte, stets davon überzeugt, die gewählten Themen und Sprachen meisterhaft zu beherrschen (siehe z.B. Sarah Lucas' viel zitierte Aussage: „Kunst ist etwas, was ich aus dem Effeff beherrsche.").

/

Umgekehrt ist das Gefühl von Scheitern und Unvermögen ein wesentliches Element von Rebecca Warrens Schaffen. Ihre Skulpturen haben Risse und ergiessen sich über offenbar falsch bemessene Sockel, ihre Vitrinen sind äusserst ungeschickt zusammengeschraubt, staubig und mit schmutzigen Plexiglasplatten abgedeckt, die nicht richtig auf die Öffnungen passen. Die Objekte, die sie in Bronze giesst, muten für das teure Material oft zu banal an, während der ungebrannte Ton ein Gefühl des Unfertigen und der Instabilität vermittelt.

/

Im zweiten Ausstellungsraum sticht eine Skulptur hervor. Sie trägt den gewichtigen Titel *The Light of the World* (2004) und steht auf

einem niedrigen bemalten Sockel. Obschon sie eigentlich aus Ton besteht, wirkt sie durch ihre Farbe, als sei sie aus Bronze gefertigt. Sie ist ca. einen Meter gross und hat die Form eines grob modellierten, sehr stark vergrösserten Kelchs. Sowohl Material als auch Form lassen auf einen heiligen Bestimmungszweck schliessen, z.B. den Heiligen Gral oder eine Verwendung als Abendmahlskelch. Doch der Stil des Kelchs biegt sich unter der unausgewogen verteilten Last des oberen Teils, und das ganze Gefäss scheint kurz davor zusammenzubrechen. Die Skulptur ist unübersehbar handgefertigt und verweist klar auf den typischen Stil der Bronzeplastiken des 19. Jahrhunderts von Rodin bis Rosso. Geht man um das Gefäss herum, entdeckt man auf der einen Seite verblüfft einen kleinen flauschigen Ball, der fast die gleiche Farbe hat wie die Skulptur und daher nahezu unsichtbar ist. Es scheint klar, dass Warren – sie erwartet dies auch vom Publikum – mehrdeutig bleiben will, was die bedeutungsschwere Symbolik ihrer Skulptur angeht, die nun plötzlich wie ein ins Monströse vergrössertes Knetgebilde eines Kindes anmutet.

/

Ungebrannter Ton, grob modellierte Formen, flauschige Pompons, sexuelle Themen und übertrieben dargestellte sexuelle Attribute; kunstgeschichtliche Bezüge, die popularisiert und zu kleinen Statuetten verarbeitet werden: Die Figur, um die es hier geht, scheint aus dieser Perspektive der Hobbykünstler zu sein.

/

Im Zusammenhang mit seinem *Birdhouse for a Bird That Is Near and a Bird That Is Far* (1979) erklärte Mike Kelley, es sei seine Absicht, „eine gewisse Abweichung von der unbewusst normativen Vorstellung des Hobbykünstlers zu ermöglichen"[5]. Kelley beanspruchte eine historische und emotionale Position ausserhalb des Gewinndiskurses und stellte die universalistischen Annahmen des Minimalismus in Frage. Rugoff vertrat 1990 die Ansicht, die Figur des Verlierers könne gegen die triumphale und triumphierende Kommerzialisierung der Kunst Ende der 80er-Jahre ins Feld geführt werden. Für Warren, ähnlich wie für Künstler wie Hesse, Trockel, Genzken und Bas Jan Ader, ist die Auseinandersetzung mit der Idee des Scheiterns eine Möglichkeit,

Unterschiedlichkeit auszudrücken und sich auf eigene Weise am Gewinndiskurs zu beteiligen, der die westliche Kunst prägt.

/

Die einzige Bronzearbeit der Ausstellung steht ganz in der Nähe. Es ist ein kleiner handmodellierter Würfel auf Rädern, der sich durch seine offensichtliche Kompaktheit von den anderen Werken abhebt. Da er ungefähr in der Mitte des Raums steht, dient er optisch als Angelpunkt, um den sich die ganze Ausstellung dreht. Das Werk, das zugleich an einen Goldbarren und an eine minimalistische Plastik erinnert, trug ursprünglich den Titel *Credit Swis* (sic), der eine Verbindung zwischen dem Ausstellungstitel und einer bestimmten Periode der Geschichte des Schweizer Bankwesens nahe legte (Warren erklärt die seltsame Schreibweise des Wortes Swiss damit, sie habe „die SS nicht erwähnen" wollen). Eine historische Perspektive findet sich ausserdem bei *Dark Passage* (2004), einer grossen Skulptur aus ungebranntem Ton, die gleich daneben zu sehen ist. Es ist ein unglaublich exzessives und unglaublich witziges Werk. Wiederum handelt es sich um eine weibliche Figur, wiederum ist sie kopflos. Aus ihren Brüsten spriessen Tentakel, die in Warrens Vokabular häufig für verminderte intellektuelle Fähigkeiten stehen und irgendwo zwischen einem Geflecht frei liegender Nerven, der Frisur einer Kurtisane und einer leeren dekorativen Verzierung anzusiedeln sind. Das mit dümmlicher Entschlossenheit vorwärts marschierende Geschöpf verkörpert tatsächlich die Strategie der vielfältigen Interpretationsmöglichkeiten, die Warrens Schaffen wesentlich prägt. Das gutmütige, an eine Comicfigur erinnernde Gesicht und der lange Hals des Tiers, auf dem diese grossbusige Dame zu reiten scheint, erweisen sich auf den zweiten Blick als drittes ausgestrecktes Bein, das einen von Warrens typischen Minnie Maus-Pumps trägt und unverkennbar im Stechschritt marschiert.

/

Im zentralen Raum der Ausstellung steht in der Nähe der Wand eine Doppelplastik mit dem Titel *The Twins* (2004). Die zwei Figuren sind klar von Degas' Skulptur *Kleine vierzehnjährige Tänzerin* (1880/81) inspiriert, die sich heute in der Tate Gallery in London befindet. Warren wählte sie in einer vor kurzem durchgeführten Umfrage des Frieze

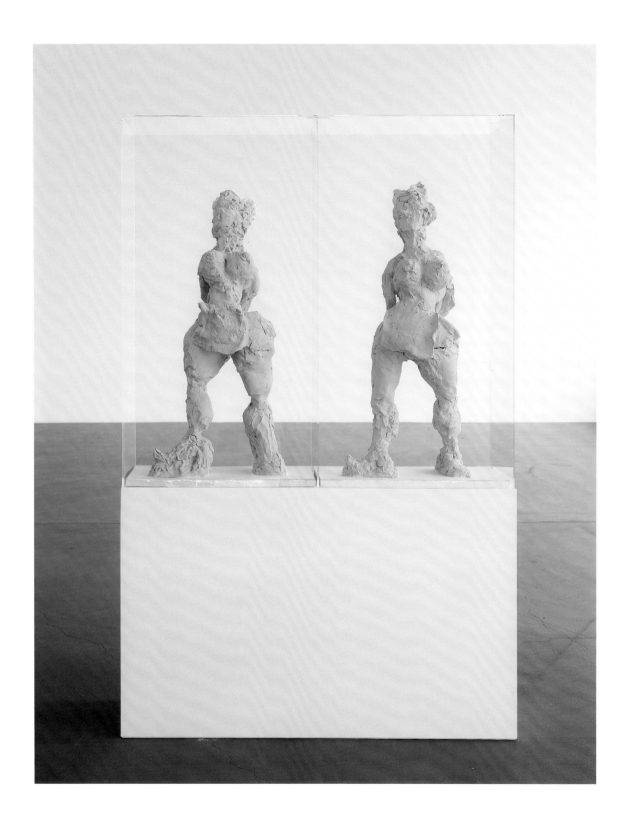

The Twins, 2004

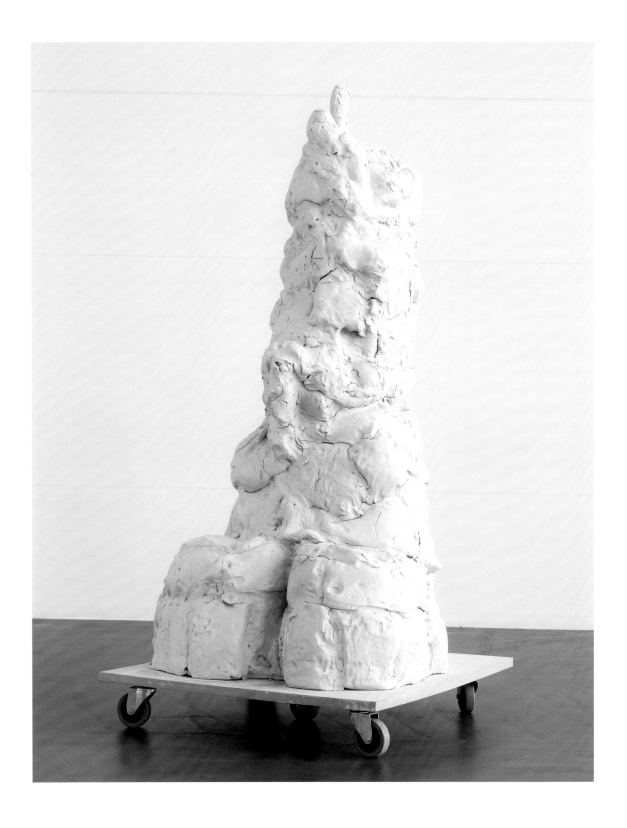

Private Schmidt, 2004

Magazine als eines von fünf Kunstwerken, die sie gern besitzen würde. Sie meinte bei dieser Gelegenheit, sie würde die Skulptur gern vor Martin Kippenbergers *Ich kann beim besten Willen kein Hakenkreuz erkennen* (1984) stellen. *The Twins* ist eines von Warrens Werken, die sich am offensichtlichsten mit der bildhauerischen Tradition beschäftigen und deren Inspirationsquelle ganz unmittelbar erkennbar ist, so dass nicht überrascht, dass es auch Warrens Ambiguität in Bezug auf jene Tradition sehr klar zum Ausdruck bringt.

/

Die kleine vierzehnjährige Tänzerin war die einzige Skulptur, die Degas zu seinen Lebzeiten ausstellte. An der Pariser Impressionisten-Ausstellung sorgte sie 1881 für eine riesige Sensation. Der Kritiker J.K. Huysmans schrieb: „Die schreckliche Wirklichkeit dieser Statuette verursacht dem Publikum ein offensichtliches Unbehagen; all seine Ideen über die Bildhauerei, über diese kalten, leblosen, weissen Erscheinungen, über diese denkwürdigen, seit Jahrhunderten wiederholten schablonenmässigen Werke werden umgestürzt. Tatsache ist, dass Monsieur Degas die Traditionen der Bildhauerkunst umgestossen hat"[6]. Degas' Skulptur mit ihrem wirklichen Mieder, ihren wirklichen Schuhen und ihrer wirklichen Haarschleife erscheint auch aus heutiger Sicht noch als ausserordentliches realistisches Kunstwerk, als völlig individualisierte und unmittelbare Darstellung eines ganz bestimmten, einzigartigen Sujets. Warren hat ihre Zwillinge auf einen hohen blassrosa Sockel gestellt und ihnen ein Plexiglasgehäuse übergestülpt, das für die Figuren gerade gross genug ist. Dieses ist in der Mitte zweigeteilt, so dass jede Zwillingsfigur in eine eigene kleine, durchsichtige Box eingeschlossen und von ihrer Gefährtin getrennt ist. Die zwei Statuen sind zwar sehr ähnlich, aber nicht identisch (Warren sagt, dass sie die beiden ursprünglich identisch gestalten wollte, aber dann feststellte, dass dies nicht nötig war). Man fühlt sich an Robert Rauschenbergs identische expressionistische Gemälde *Factum 1* und *Factum 2* (1957) erinnert, an Sturtevants Warhol-Kopien, an Haim Steinbachs Arrangements, an Francis Bacons Glaskästen. Man denkt dabei aber auch an eine Schiessbude, an eine Auslage riesiger Puppen, wie sie vielleicht in einem Film Noir der 40er Jahre vorkommt.

Wie im Vergleich mit Warrens Neubearbeitung deutlich wird, ist Degas' Skulptur in vielerlei Hinsicht auch eine Darstellung der Unschuld: „Ein Mädchen, das noch nicht ganz Frau und noch nicht in Sünde gefallen ist"[7] – das Werk eines Künstlers und einer Zeit, die von den Figuren der Prostituierten und der Kurtisane besessen waren. Degas meinte in Zusammenhang mit seinem Schaffen: „Akte sind immer in Posen dargestellt worden, die ein Publikum voraussetzen. Aber meine Frauen sind einfache Menschen, ehrenhafte, sie kümmern sich um nichts weiter als um ihre eigene Physis. Da ist eine, die sich die Füsse wäscht. Es ist, als ob man durch ein Schlüsselloch blickt."[8] Warren hat ihre Mädchen mit unschuldigen Schleifen, ausladenden Waden, Plateauschuhen sowie einer winzigen Schürze ausgestattet, wie man sie immer noch hie und da bei Kellnerinnen in besonders unerfreulichen Bierlokalen vor allem in Bayern und der Schweiz findet. Diese zwei vollbusigen Hausfrauen, die bereit sind für eine erotische Peepshow, sind mit dem Gesicht zur Wand und dem entblössten Hintern zur Raummitte aufgestellt – eine Geste, die für Warren typisch ist. Sie drehen dem Publikum also buchstäblich den Rücken zu, geniessen in echt postfeministischer Weise ihre Rolle als Objekte des Blicks und sind bereit, die Tür aufzustossen und Degas' peinliche Erektion zu offenbaren.
/

Wilde Kreativität, „kunstgeschichtliche Launenhaftigkeit"[9] und stilisierter Wahnsinn prägen die im letzten Ausstellungsraum gezeigte Werkgruppe. Die kleinen Skulpturen sind auf hohen weissen oder blassrosa Sockeln platziert; dabei mischen sich glasierter und unglasierter Ton, und normalerweise blasse Farben werden von Klecksen in leuchtendem Kadmium und Goldakzenten unterbrochen. Die meisten scheinen unterschiedliche Formen der Kopulation darzustellen. Dies ist zweifellos ein Raum, in dem man herumspazieren und sich einzelne Arbeiten ansehen soll, auf die man dann zurückkommt. Einige der Skulpturen sind vorwiegend rund gestaltet und können aus einer Perspektive von 360 Grad betrachtet werden; andere haben eine eindeutige Rückseite. Manche spielen auf andere Kunstwerke an, insbesondere auf Arbeiten von Otto Dix. So lassen sich die durchlöcherten Beine des *Hundemeisters* (2004) auf das mittlere Tafelbild von Dix' Triptychon

Der Krieg (1929–32) zurückführen, vielleicht via Georg Baselitz, während *Lustmord III* (2004) auf Dix' unglaublich grausiges Gemälde und die Radierung mit demselben Titel (beide 1922) Bezug nimmt.

Älteres Liebespaar (2004) ist eine dreidimensionale Darstellung von Dix' Gemälde *Ungleiches Liebespaar* von 1925. Bei Warren sind die Liebenden jedoch nicht mehr ungleich, und die extravagant frisierte Dame (die unbestreitbar Herrin der Lage ist, obschon ihr ein Arm amputiert ist und sie blutet) reitet stolz auf einem breitschultrigen, kräftigen grünen Mann und nicht auf einem gebrechlichen Greis wie bei Dix. Andere Objekte bewegen sich am Rande der Erkennbarkeit: Einzelne Körperteile scheinen aus ansonsten nicht aufschlüsselbaren Gebilden aufzutauchen oder darin zu verschwinden. Auch können körperlose Anatomieteile wie vergoldete Vaginen, Penisse, Brüste oder Füsse aus den nicht narrativen, unbestimmten Gefilden am Rande des zentralen Schauplatzes emportauchen. Das Betrachten des Werks wird so zu einem komplexen und bedeutsamen Unternehmen, zu einem bewussten Forschungsakt. Die Sockel sind alle gleich gross und gleich hoch, mit Ausnahme der beiden blassrosa Exemplare, die etwas höher sind. Einige Skulpturen wachsen über ihren Sockel hinaus und scheinen in ständiger Gefahr, auf den Boden zu stürzen; so etwa die männliche Figur, die auf ein weibliches Gesicht ejakuliert – *The Pearls of Switzerland* (2004) – oder der rätselhafte grün-braun-rosa Klumpen, in dem ich einen Pferdekopf zu erkennen glaubte. Oft scheint den sexuellen Aktivitäten, in die alle verwickelt sind, etwas Unheilvolles anzuhaften. Die Unterleiber der Frauen weisen häufig Blutspuren auf, die Körpermassen scheinen näher an Neuinterpretationen von Rodins *Höllentor* als an Vorstellungen von freier Sexualität der 70er Jahre zu sein. Da ist auch eine hübsche kleine weisse Skulptur mit dem Titel *O.D.* (2004), während sich üppige vergoldete Damen auf Sesseln mit unterschiedlich gemusterten Ginghambezügen zur Schau stellen und Dix' altes Liebespaar der ganzen Installation einen Anflug von kleinbürgerlicher Düsternis verleiht.

/

Wenn man auf die ganze Ausstellung und das komplexe Gewebe von Interessen, Umwegen, Verweisen und verzögerten Reaktionen zurückblickt,

fühlt man sich an Jennifer Higgies Kommentar zu *Croccioni* (2000) erinnert, Warrens Interpretation von Boccionis *Einzigartige Formen der Kontinuität im Raum* (1913): „Wie Warrens beste Skulpturen macht das Werk ihren Kampf spürbar – mit Prozessen und Prioritäten, mit Irregularität und Erkundung, mit der Tatsache, hinzuschauen und nochmals hinzuschauen, um gerade dann seine Meinung zu ändern, wenn man meint, man habe es erfasst."[10] Prozesse und Sprache sind meiner Ansicht nach für Warrens Kunst von zentraler Bedeutung.

/

Laut Freud ist die Geschichte des Patienten nicht in irgendeiner ursprünglichen Wahrheit zu finden, die hinter der Assoziationskette zum Vorschein kommt, sondern im Prozess selbst. Dieser Prozess wird schnell damit in Verbindung gebracht, dass Sprache in der wechselnden Beziehung zwischen einzelnen Begriffen Bedeutung erzeugt. In gewisser Weise bringt sich Warren als Zeichen und als Glied in der Kette gleicher und voneinander abhängiger Signifikanten in ihr Schaffen ein; sie scheint eine Rolle in einer Geschichte zu spielen und sich nicht mit der Rolle der Autorin zufrieden zu geben. Ihre Skulpturen – eindeutig handmodelliert und eindeutig das Resultat eines Kampfes – scheinen das Ergebnis eines Selbstanalyse- und Selbstdarstellungsprozesses und zugleich ein Abbild dieses Prozesses zu sein. Sie scheinen einerseits die Freuden einer unverfälschten Individualität zu geniessen und sich anderseits der ihr innewohnenden leichten Komik sehr bewusst zu sein. Warren greift Übersetzungsfehler und teilweise Missverständnisse auf und verwendet eine Fülle beabsichtigter Anspielungen und Assoziationen, die wiederum zu einer Vielzahl unbeabsichtigter Deutungen führt. Indem sie gleichzeitig auf Handwerklichkeit und Scheitern und auf dem ständig demonstrierten Schwanken zwischen dem Unbeholfenen und dem Meisterhaften besteht, spinnt sie die erwartete Erzählung mit Abweichungen weiter. Themen wie Geschichte, Geschlecht, Tradition, Individualität, Selbstdarstellung, Meisterschaft erscheinen sowohl als Teil ihres Schaffens als auch als Symbole ihrer eigenen Geschichte, als Elemente, deren Zusammenwirken die wahre Freude der künstlerischen Tätigkeit und die Liebe zu unserem Erbe möglich macht.

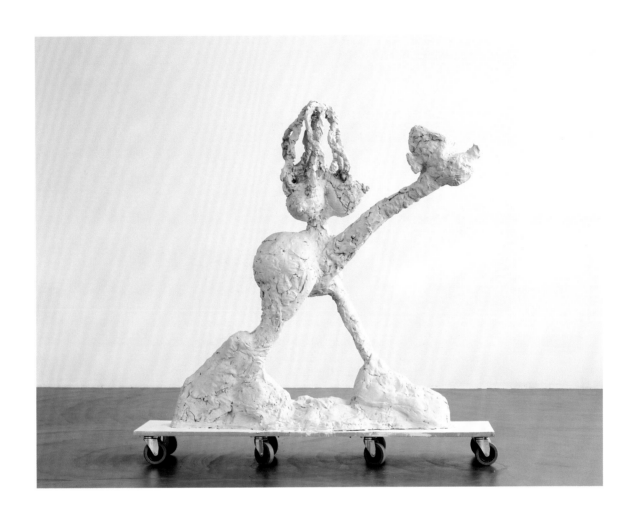

Dark Passage, 2004

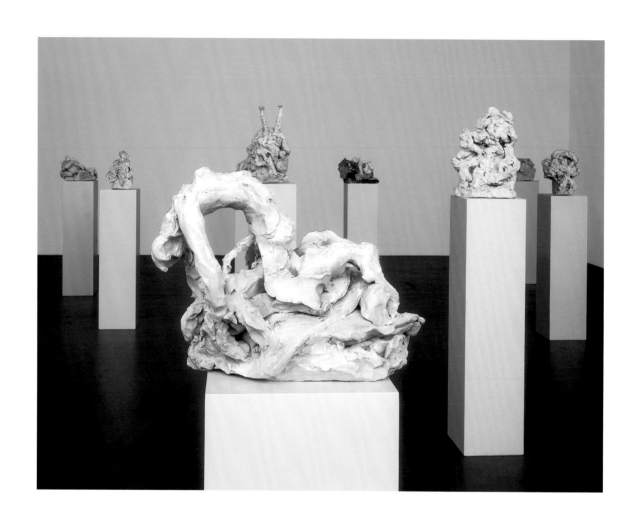

Installation view / Installationsansicht
Dark Passage, Kunsthalle Zürich

Foreground / Vordergrund:
The Pearls of Switzerland, 2004

Schliesslich gilt es zu bedenken, dass eine gewisse bewusste Irreführung in Warrens Schaffen nicht selten ist. So hat sie vor kurzem eine Ausstellung *She* genannt und erklärt, sie habe sich durch den von den Hammer-Studios produzierten, unglaublich stumpfsinnigen Film gleichen Titels mit Ursula Andress in der Hauptrolle inspirieren lassen. Oder sie hat freundlicherweise zu einer Ausstellung bei Modern Art in London eine begeisterte, übertrieben formulierte Pressemitteilung[11] herausgegeben, die nur auf Deutsch verbreitet wurde. Der letzte Satz lautete folgendermassen: „Uns geht es hier nicht um Bierkellermentalität, sondern um den halluzinatorischen sozialen Verkehr, der ensteht, wenn Jägermeister das verwundene Paar von Willen und Libido tränkt."

1 Levines Statement beginnt mit einem Zitat von Franz Marc und endet mit einer Variation zur Schlussfolgerung von Roland Barthes' „Der Tod des Autors." Abgedruckt in: *Art and Theory 1900 - 1990*, Charles, Harrison / Paul, Wood (Hrsg.), Blackwell, Oxford / Cambridge: 1993.

2 Aus „Notebook 22", in: *Degas by Himself. Drawings, prints, paintings, writings*. Richard Kendall (Hrsg.), Time Warner Books, London: 2004, S. 39

3 Diese Vitrinen erinnern auch an Experimente aus Warrens Anfangsjahren, die sie zum Teil in Zusammenarbeit mit Fergal Stapleton durchführte und die in der Galerie aus einfach verfügbaren Materialien entstanden.

4 Ralph Rugoff, *Just Pathetic*, Rosamund Felsen Gallery, Los Angeles: 1990.

5 Elisabeth Sussman, „Introduction", in: *Mike Kelley: Catholic Taste*, Whitney Museum of American Art, New York: 1994, S. 20.

6 Linda Nochlin, *Realism*, Penguin Books, London: 1990, S. 269.

7 Ebenda, S. 206.

8 „Edgar Degas to George Moore", in: *The Visual Art: A History*, Honour and Fleming, Macmillan Publishers, Basingstoke Hampshire: 1982, S. 551.

9 Jennifer Higgie, „Under the Influence", in: *Frieze*, Januar / Februar 2003, S. 67.

10 Ebenda.

11 Carl Freedman, „Fleischvater", press release, Modern Art, London: November / Dezember 2002.

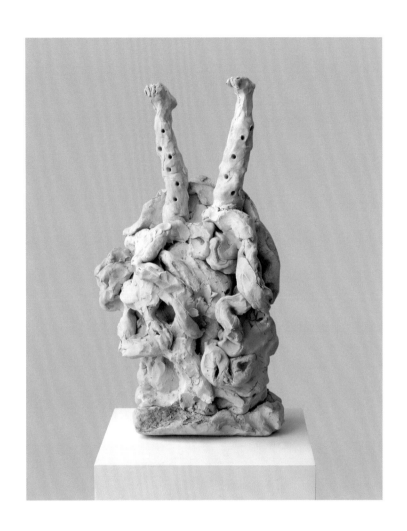

Hundemeister, 2004

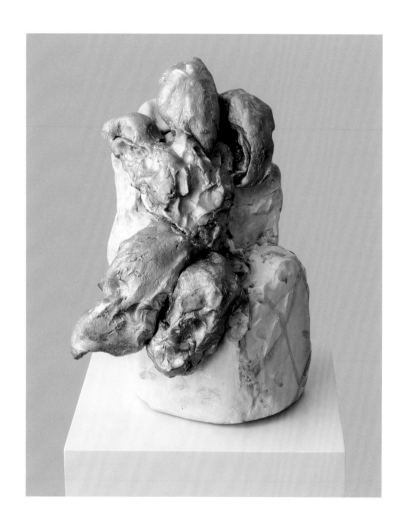

Saperstein, 2004

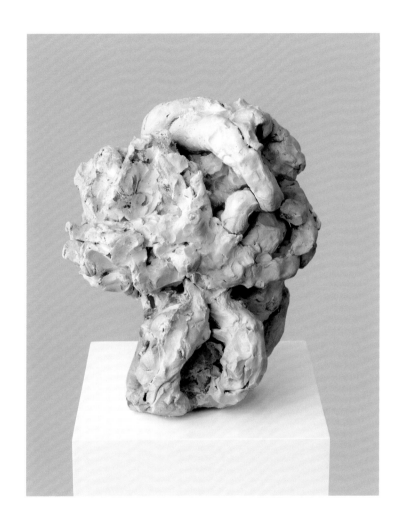

Alpine, 2004

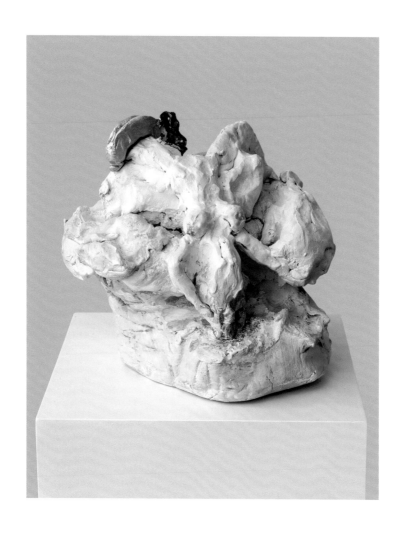

Rose Garden, 2004

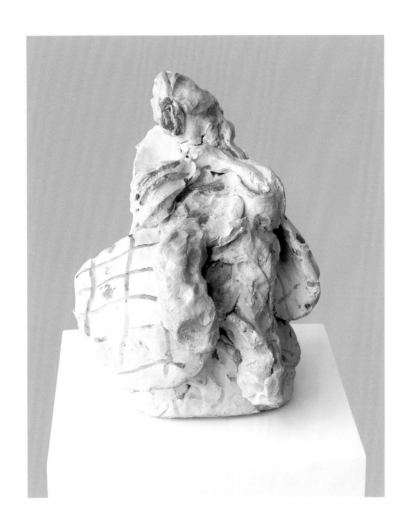

Bildnis des Juweliers, 2004

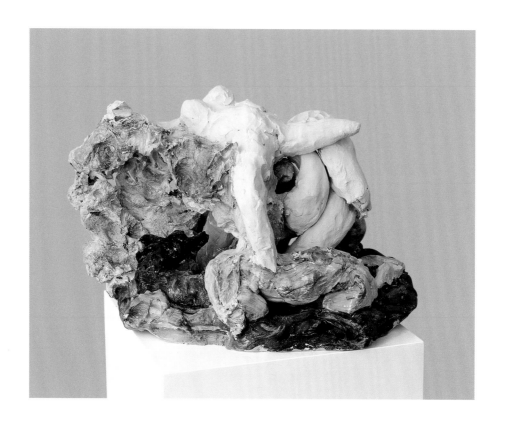

Römische Kerze, 2004

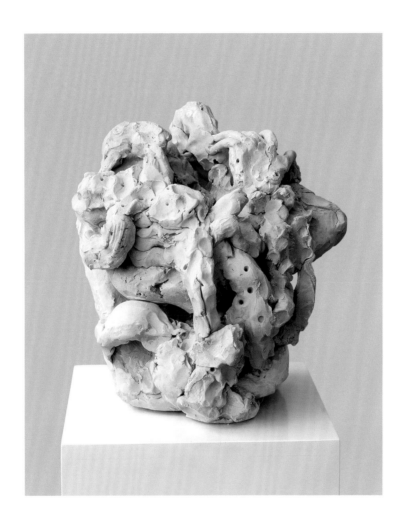

The Flawed Pedagogy of the Sausage-Maker, 2004

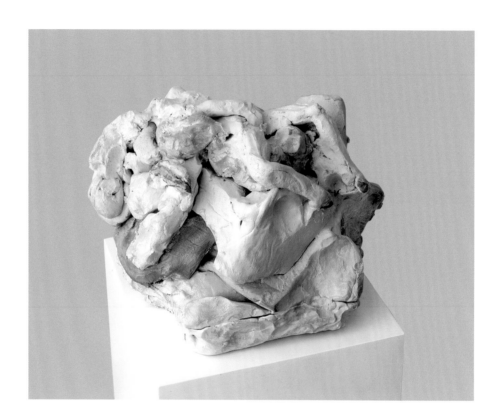

Lustmord III, 2004

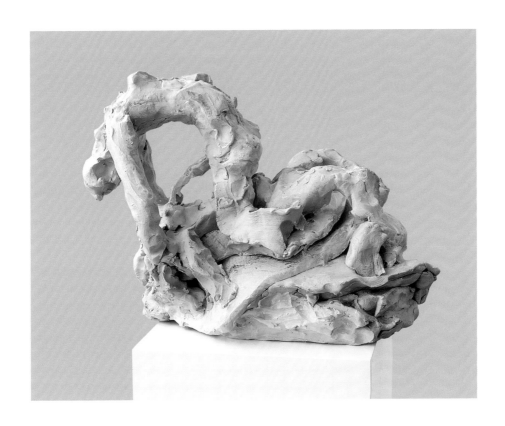

The Pearls of Switzerland, 2004

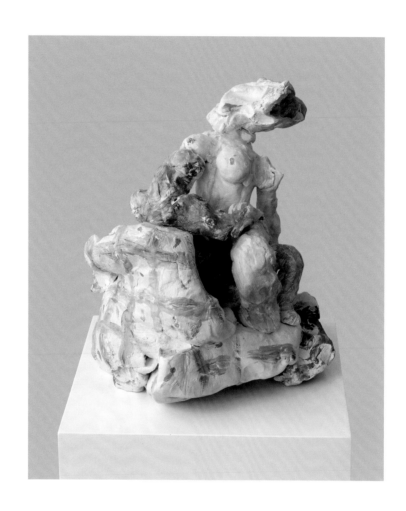

Älteres Liebespaar, 2004

O.D., 2004

Commando, 2004

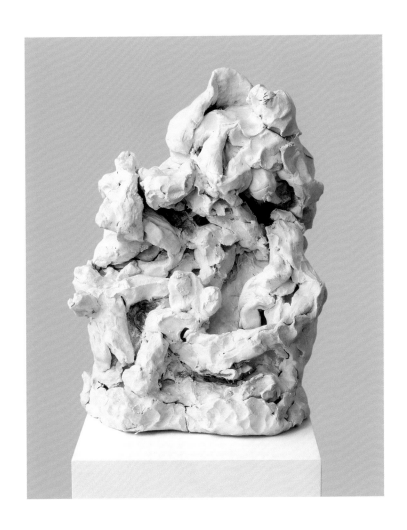

Der Krieg, 2004

BIOGRAPHY / BIBLIOGRAPHY
BIOGRAFIE / BIBLIOGRAFIE

Born 1965 in London / Lives and works in London

1989 – 1992	BA (Hons) Fine Art, Goldsmiths College, University of London
1992 – 1993	MA Fine Art, Chelsea College of Art, London
1993 – 1994	Artist in residence, Ruskin School, Oxford University, Oxford

SOLO EXHIBITIONS/
EINZELAUSSTELLUNGEN

2005 Matthew Marks Gallery, New York
Galerie Daniel Buchholz, Köln

2004 *Dark Passage*, Kunsthalle Zürich, Zürich
Family Badge, Antiquariat Buchholz, Galerie
Daniel Buchholz, Köln

2003 Donald Young Gallery, Chicago
The Boiler Room, The Saatchi Gallery, London
She, Maureen Paley Interim Art, London

2002 *Fleischvater*, Modern Art, London

2000 *The Agony and the Ecstasy*, Maureen Paley
Interim Art, London

1995 *Manliness without ostentation...*, the Agency,
London

1993 *I Have Every Vice in the World*, Dolphin Gallery,
Oxford

COLLABORATIONS/
KOLLABORATIONEN

1997 Fergal Stapleton and/und Rebecca Warren,
The Showroom, London

1996 Rebecca Warren and/und Fergal Stapleton,
Cleveland, London

1995 Rebecca Warren, Fergal Stapleton and/
und Graham Gussin, Laure Genillard, London

1994 *Retrospective: Your Mother*, with/mit Fergal
Stapleton, 152c Brick Lane, London

GROUP EXHIBITIONS/
GRUPPENAUSSTELLUNGEN

2004 *Strange, I've seen that face before*, Gallery
of Modern Art, Glasgow
Collage, Bloomberg Space, London

2003 *Frass*, 153-155 Grays Inn Road, London
Rachel Harrison, Hirsch Perlman, Dieter Roth,
Jack Smith, Rebecca Warren, Matthew Marks
Gallery, New York
4 Old Works, 56a Clerkenwell Road, London

2002 *The Galleries Show*, Royal Academy of Arts,
London
Summer Exhibition 2002, Royal Academy of
Arts, London

2001 Neon Gallery, London
Tattoo Show, Modern Art, London
New Labour, The Saatchi Gallery, London

1999 *Limitless*, Galerie Krinzinger, Wien
Day of the Donkey Day, Transmission, Glasgow
It's a Curse it's a Burden, The Approach, London

1998 *Root*, Chisenhale Gallery, London
The Kindness of Strangers, W139 Gallery,
Amsterdam
Craft, Richard Salmon, London
(travelled to Kettle's Yard, Cambridge)
Bank, Institute of Contemporary Art, London

1997 *Martin*, Commercial Gallery and/und 146 Brick
Lane, London
Class Vegas, The Embassy, London
Material Culture; Sculpture from the 80s and 90s,
Hayward Gallery, London

1996 *Light*, Richard Salmon, London
(travelled to Spacex Gallery, Exeter)
Happy Shopper, Elephant & Castle Shopping
Centre, London
Dog U Mental VIII, Bank, London
Berlin Art Fair, Berlin
NIS Project at world PC Expo, Tokyo
On Camp/Off Base: Pimple Life, Tokyo
Big Sight Exhibition Centre, Tokyo
Out of Space, Cole and Cole, Oxford
Fuck Off, Bank, London
Disneyland After Dark: La Ronde, Künstlerhaus
Bethanien, Berlin
I Beg to Differ, Milch, London

1995 *Happy Squirrels Club*, Bank, Eindhoven
Model Home, PS1, The Clocktower Gallery,
New York
The Meaning of Life..., Art Node Foundation
The Meaning of Life..., parts 1 & 2, CCA, Glasgow
Cocaine Orgasm, Bank, London
Disneyland After Dark: La Ronde, Konstmuseum,
Uppsala
Insignificance, the Agency, London
Stockholm Art Fair

1994 *Miniatures*, the Agency, London
Destroy All Monsters, The Tannery, London
Mind the gap..., Acud Galerie, Berlin
Mind the gap..., Hardcopys und technologische
Bilder, Galerie/Edition, Voges & Deisen,
Frankfurt

1993 *Whitworth Young Contemporaries*, The Whitworth
Act Gallery, Manchester

SELECTED BIBLIOGRAPHY/
AUSGEWÄHLTE BIBLIOGRAPHIE

2004 Charlesworth, JJ, "The Maker's Mark," *Spike Art Quarterly*, Wien, December 2004

Hilty, Greg: "Rebecca Warren: SHE," *Parkett*, N° 70, Zürich/New York 2004

O'Grady, Carrie, "What's Up With Modern Art? Rebecca Warren," *The Guide (Frieze Art Fair)*, London, October 2004

Charlesworth, JJ, "Twisted Sister," *Art review*, June 2004

2003 Somaiya, Ravi, *Frass, Dazed & Confused*, October 2003

Hawkins, Margaret, "The surreal world," *Chicago Sunday Times*, October 24, 2003

Artner, Alan G., "Warren's rough, eloquent art," *Chicago Tribune*, October 10, 2003

Coomer, Martin, "New acquisitions in the Boiler Room," *Time Out Saatchi Gallery Guide*, October 1–8, 2003

Brooks, Libby, "Top Girls, 50 women to watch," *Guardian G2*, September 30, 2003

Anderson, Hephzibah, "Clay pride," *Metro Life*, September 26–October 2, 2003

Burton, Johanna, "Rachel Harrison, Hirsch Perlman, Dieter Roth, Jack Smith, Rebecca Warren," *Time Out New York*, August 7–14, 2003

Smith, Roberta, "A Grand hale of Group Show Fireworks," *The New York Times*, July 18, 2003

[Red.], "Rebecca Warren," *kulturflash*, N° 52, July 15, 2003

Pethick, Emily, "Rebecca Warren," *Artforum.com*, June 2003

Kent, Sarah, "Rebecca Warren," *Time Out*, June 18-25, 2003

Higgie, Jennifer, "Under the Influence," *frieze*, January/February, 2003

2002 Güner, Fisun, "Glad to be clay," *Metro UK*, December 9, 2002

Coomer, Martin, "Vogue's galleries," *Time Out*, N° 1675 September 25–October 2, 2002

Dorment, Richard, "Academy of Cool," *The Daily Telegraph*, June 5, 2002

Charlesworth, JJ., "Neon Gallery," *contemporary*, March 2002

Aidin, Rose & Williamson, Charlotte, "Move over Damien, meet the new talent," *The Evening Standard, ES Magazine*, September 12, 2002

Kent, Sarah, "The Tattoo Show, Modern Art," *Time Out*, N° 1613, July 18-25, 2002

Ellis, Patricia, "New Labour @ Saatchi," *Flash Art*, Vol. XXXIV, N° 218, May/June 2002

Sewell, Brian, "A touch of smut with a hand from Saatchi," *The Evening Standard*, May 18, 2002

Wilsher, Mark, "Craftwork," *What's On*, May 9-16, 2002

Kent, Sarah, "Labour intensive: Object lessons from New Labour at the Saatchi," *Time Out*, N° 1603, May 9-16, 2002

Dorment, Richard, "Art for the eyes, not the brain," *The Daily Telegraph*, May 2, 2002

Cork, Richard, "What's hot in the year of our Trace," *The Times*, May 2, 2002

Januszczak, Waldemar, "At the Saatchi Gallery, you'll find proof that New Labour really is working," *The Sunday Times*, Culture section, April 29, 2002

Darwent, Charles, "Handmade tales of pots and porn," *The Independent on Sunday, Culture*, April 29, 2002

Cumming, Laura, "New Labour, Saatchi Gallery," *The Observer Review*, April 29, 2002

Gellatly, Andrew, "Rebecca Warren, Interim Art," *frieze*, Issue 56, January/February 2002

Gleeson, David, "The Raw and the Cooked," *britart.com*, November 2002

Archer, Michael, "Going for Bronze," *Art Monthly*, N° 240, October 2002

Coomer, Martin, "Rebecca Warren Interim Art (Critic's Choice)", *Time Out*, N° 1571, September 27-October 4, 2002

Musgrave, David, "It's a curse, it's a burden," *Art Monthly*, N° 223 February, 2002

Herbert, Martin, "It's a curse, it's a burden," *Time Out*, N° 1482, January 13-20, 2002

LIST OF WORKS / ABBILDUNGSVERZEICHNIS

p. 2 New York Dolls
 New York Tapes 72 / 73

p. 3 Pablo Picasso
 Les Demoiselles d'Avignon, 1907
 Oil on canvas / Öl auf Leinwand
 243.9 x 233.7 cm
 Museum of Modern Art, New York

p. 21 *Helmut Crumb*, 1998
 Reinforced clay, MDF, stacked plinths /
 Faserverstärkter Ton, MDF, geschichtete Sockel
 19 x 30.5 x 30.5 cm
 The Cranford Collection, London
 Courtesy Maureen Paley, London

p. 22 *Pony*, 2003
 Reinforced clay, acrylic paint, plinth /
 Faserverstärkter Ton, Acryl, Sockel
 94 x 27 x 57 cm
 Private collection / Privatsammlung, London
 Courtesy Maureen Paley, London

p. 23 *Delacroix*, 2003
 Reinforced clay, pom pom, plinths /
 Faserverstärkter Ton, Pompom, Sockel
 130 x 28 x 26 cm
 Courtesy Matthew Marks Gallery, New York

p. 25 *Girl 38*, 2003
 Reinforced clay, twig, plinth /
 Faserverstärkter Ton, Zweig, Sockel
 88 x 57 x 81 cm
 Collection Brooke and Daniel Neidich,
 New York
 Courtesy of Matthew Marks Gallery, New York

p. 26 *Deutsche Bank*, 2002
 Reinforced clay, MDF, wheels /
 Faserverstärkter Ton, MDF, Rollen
 166 x 74 x 74 cm
 Collection Stanley & Gail Hollander
 Courtesy Maureen Paley, London

p. 31 *She*, 2003
 In 7 parts, reinforced clay, MDF, wheels /
 7-teilig, faserverstärkter Ton, MDF, Rollen
 Dimensions variable / Grösse variabel
 From left to right / Von links nach rechts:
 Untitled, 2003
 Reinforced clay, MDF, wheels /
 Faserverstärkter Ton, MDF, Rollen
 198 x 46 x 77 cm

 Homage to R. Crumb, My Father, 2003
 Reinforced clay, MDF, wheels /
 Faserverstärkter Ton, MDF, Rollen
 213 x 81.5 x 81.5 cm
 No. 6, 2003
 Reinforced clay, MDF, wheels /
 Faserverstärkter Ton, MDF, Rollen
 186 x 61 x 122 cm
 South Kent, 2003
 Reinforced clay, MDF, wheels /
 Faserverstärkter Ton, MDF, Rollen
 206 x 127 x 66 cm
 All works / Alle Arbeiten
 The Saatchi Gallery, London
 Courtesy Maureen Paley, London

p. 32 *Every Aspect of Bitch Magic*, 1996
 Mixed media / Verschiedene Materialien
 132 x 30 x 30 cm
 Collection of the artist / Besitz der Künstlerin

p. 33 *Bitch Magic: The Musical*, 2001 – 2003
 Mixed media / Verschiedene Materialien
 139.7 x 48.9 x 34.3 cm
 Courtesy Donald Young Gallery, Chicago

p. 35 *Croccioni*, 2000
 Reinforced clay, plinths /
 Faserverstärkter Ton, Sockel
 85 x 34 x 84 cm
 The Saatchi Gallery, London
 Courtesy Maureen Paley, London

p. 39 *Tunnel in the mountains, between Yale and Boston*
 Bar, British Columbia, 1881
 Library and Archives Canada / Sir Sandford
 Fleming fonds / C – 007660
 Credit: Richard Maynard

p. 45 *Log Lady*, 2003
 Reinforced clay, log, MDF, wheels /
 Faserverstärkter Ton, Baumstamm, MDF, Rollen
 199 x 129 x 120 cm
 The Cranford Collection, London

p. 46 *Reingold*, 2004
 Mixed media / Verschiedene Materialien
 186 x 44 x 34 cm
 Collection of the artist / Besitz der Künstlerin

p. 51 Installation view / Ausstellungsansicht
 Dark Passage, Kunsthalle Zürich, 2004
 From left to right / Von links nach rechts:

 The Twins, 2004
 Reinforced clay, Perspex vitrine, plinth /
 Faserverstärkter Ton, Plexiglasvitrine, Sockel
 200 x 132 x 36 cm
 Private collection / Privatsammlung
 Dark Passage, 2004
 Reinforced clay, MDF, wheels /
 Faserverstärkter Ton, MDF, Rollen
 195 x 198 x 45.5 cm
 Kunsthaus Zürich
 Cube, 2003
 Bronze, MDF, wheels /
 Bronze, MDF, Rollen
 51 x 35 x 37.5 cm
 The Cranford Collection, London
 The Light of the World, 2004
 Reinforced clay, acrylic paint, pompom /
 Faserverstärkter Ton, Acryl, Pompom
 112 x 34 x 34 cm
 Private collection / Privatsammlung
 Teacher (M.B.), 2003
 Reinforced clay, MDF, wheels /
 Faserverstärkter Ton, MDF, Rollen
 214.6 x 102.9 x 74.3 cm
 Private collection, Spain /
 Privatsammlung, Spanien
 Courtesy Donald Young Gallery, Chicago

p. 52 *The Light of the World*, 2004
 Reinforced clay, acrylic paint, pompom /
 Faserverstärkter Ton, Acryl, Pompom
 112 x 34 x 34 cm
 Private collection / Privatsammlung

p. 60 – 61 *I Love the Sound of Breaking Glass*, 2004
 Mixed media / Verschiedene Materialien
 In 3 parts, 43 x 180 x 31 cm each
 3-teilig, je 43 x 180 x 31 cm
 Dimitris Daskalopoulos Collection, Greece /
 Griechenland
 Courtesy Maureen Paley, London

p. 62 *Cube*, 2003
 Bronze, MDF, wheels /
 Bronze, MDF, Rollen
 51 x 35 x 37.5 cm
 The Cranford Collection, London

p. 67 *The Twins*, 2004
Reinforced clay, Perspex vitrine, plinth /
Faserverstärkter Ton, Plexiglasvitrine, Sockel
200 x 132 x 36 cm
Private collection / Privatsammlung

p. 68 *Private Schmidt*, 2004
Reinforced clay, MDF, wheels /
Faserverstärkter Ton, MDF, Rollen
185 x 91 x 91 cm
Collection Eva Presenhuber, Zürich

p. 73 *Dark Passage*, 2004
Reinforced clay, MDF, wheels /
Faserverstärkter Ton, MDF, Rollen
195 x 198 x 45.5 cm
Kunsthaus Zürich

p. 74 Installation view / Ausstellungsansicht
Dark Passage, Kunsthalle Zürich, 2004
Foreground / Vordergrund:
The Pearls of Switzerland, 2004
Reinforced clay, acrylic paint /
Faserverstärkter Ton, Acryl
37 x 40 x 24 cm
Gregorio Magnani, London

p. 77 *Hundemeister*, 2004
Reinforced clay, acrylic paint /
Faserverstärkter Ton, Acryl
49 x 23 x 21 cm
Private collection / Privatsammlung

p. 78 *Saperstein*, 2004
Reinforced clay, acrylic paint /
Faserverstärkter Ton, Acryl
37 x 28 x 31 cm
Collection of the artist / Besitz der Künstlerin

p. 79 *Alpine*, 2004
Reinforced clay, acrylic paint /
Faserverstärkter Ton, Acryl
35 x 31 x 24 cm
Private collection / Privatsammlung

p. 80 *Rose Garden*, 2004
Reinforced clay, acrylic paint /
Faserverstärkter Ton, Acryl
25 x 25 x 23 cm
Collection of the artist / Besitz der Künstlerin

p. 81 *Bildnis des Juweliers*, 2004
Reinforced clay, acrylic paint /
Faserverstärkter Ton, Acryl
31 x 23 x 21 cm
Private collection / Privatsammlung

p. 82 *Römische Kerze*, 2004
Reinforced clay, acrylic paint /
Faserverstärkter Ton, Acryl
25 x 40 x 30 cm
Private collection / Privatsammlung

p. 83 *The Flawed Pedagogy of the Sausage-Maker*, 2004
Reinforced clay, acrylic paint /
Faserverstärkter Ton, Acryl
34 x 31 x 23 cm
Shelley Bransten, San Francisco

p. 84 *Lustmord III*, 2004
Reinforced clay, acrylic paint /
Faserverstärkter Ton, Acryl
25 x 33 x 28 cm
Private collection / Privatsammlung, Kastellorizo

p. 85 *The Pearls of Switzerland*, 2004
Reinforced clay, acrylic paint /
Faserverstärkter Ton, Acryl
37 x 40 x 24 cm
Gregorio Magnani, London

p. 86 *Älteres Liebespaar*, 2004
Reinforced clay, acrylic paint /
Faserverstärkter Ton, Acryl
30 x 21 x 23 cm
Private collection / Privatsammlung

p. 87 *O.D.*, 2004
Reinforced clay, acrylic paint /
Faserverstärkter Ton, Acryl
25 x 35 x 30 cm
Collection Maureen Paley, London

p. 88 *Commando*, 2004
Reinforced clay, acrylic paint /
Faserverstärkter Ton, Acryl
22 x 29 x 31 cm
Private collection / Privatsammlung

p. 89 *Der Krieg*, 2004
Reinforced clay, acrylic paint /
Faserverstärkter Ton, Acryl
45 x 33 x 29 cm
Private collection / Privatsammlung

IMPRINT / IMPRESSUM

Diese Publikation erscheint anlässlich der Ausstellung /
This publication is published in conjunction with the exhibition:

Rebecca Warren, *Dark Passage*, Kunsthalle Zürich, April 3 – May 30, 2004 / 3. April – 30. Mai 2004

Editor / Herausgeberin:
Beatrix Ruf, Kunsthalle Zürich

Design Concept / Grafisches Konzept:
Rebecca Warren

Typesetting and Layout / Satz und Herstellung:
Fabian Monod

Editing / Redaktion:
Beatrice Steiner

Cover / Umschlag:
The Committee
Left to right: (seated) Freud, Sàndor Ferenczi,
and Hanns Sachs; (standing) Otto Rank, Karl Abraham,
Max Eitingon, and Ernest Jones
Berlin, 1922, Becker Maas photographic studio
Courtesy The Library of Congress, USA

Proofreading / Korrektorat:
Rowena Smith, Salome Schnetz

Translations / Übersetzungen:
Jeremy Gaines (Deutsch-Englisch / German–English);
Irene Aeberli (Magnani), NANSEN (Interview)
(Englisch-Deutsch / English-German)

Photo Credits / Fotonachweis:
A. Burger

Printed by / Gesamtherstellung:
Musumeci S. p. A., Quart (Aosta), Europe

ISBN
3–905701–33–2

PUBLISHED BY / VERLAG

JRP|Ringier
Letzigraben 134
8047 Zürich
Switzerland
T +41 (0)43 311 27 50
F +41 (0)43 311 27 51
E info@jrp-ringier.com
www.jrp-ringier.com

JRP|Ringier books are available internationally
at selected bookstores and the following distribution
partners:

Switzerland

Buch 2000, AVA Verlagsauslieferung AG, Centralweg 16,
CH-8910 Affoltern a. A., buch2000@ava.ch, www.ava.ch

France
Les Presses du réel, 16 rue Quentin, F-21000 Dijon,
info@lespressesdureel.com, www.lespressesdureel.com

Germany and Austria
vice versa vertrieb, Immanuelkirchstrasse 12,
D-12405 Berlin, info@vice-versa-vertrieb.de,
www.vice-versa-vertrieb.de

UK
Art Data, 12 Bell Industrial Estate, 50 Cunnington Street,
London W4 5 HB, info@artdata.co.uk, www.artdata.co.uk

USA
D.A.P. / Distributed Art Publishers, l55 Sixth Avenue,
2nd Floor, New York, NY 10013, dap@dapinc.com,
www.artbook.com

Other countries
IDEABooks, Nieuwe Herengracht 11,
1011 RK Amsterdam, idea@ideabooks.nl,
www. ideabooks.nl

For a list of our partner bookshops or for any general
questions, please contact JRP|Ringier directly or visit our
homepage for further information about our program.

ACKNOWLEDGEMENTS / DANK

Kunsthalle Zürich and Rebecca Warren would like
to thank / Kunsthalle Zürich und Rebecca Warren danken:

Präsidialdepartement der Stadt Zürich
Luma Stiftung
British Council

Irene Aeberli, Rahel Blättler, Dany Boller, Lionel Bovier,
Elisabeth Brockmann, JJ Charlesworth, Bice Curiger,
Carl Freedman, Jeremy Gaines, Gilles Gavillet, Dan Gunn,
Jennifer Higgie, Greg Hilty, Marcel Koch, Boris Knorpp,
James Lavender, Emily Letourneau, Gregorio Magnani,
Matthew Marks Gallery, Barbara Mosca, Flavio Morganti,
Max Mugler, Gregor Muir, Alfonso Negri, Maureen Paley,
Sandra Porchet, Andrew Renton, Muriel Salem,
Beatrice Steiner, Adrian Turner, Nina Weber,
Donald Young Gallery (Chicago), Donald Young.

Many thanks to the following lenders /
Dank an die Leihgeber:

Rebecca Warren, Maureen Paley / Interim Art (London),
The Cranford Collection (London), Matthew Marks
Gallery (New York) and private lenders who wish to
remain anonymous / und Leihgebern, die nicht genannt
werden möchten.

Kunsthalle Zürich
Limmatstrasse 270
8005 Zürich
Switzerland / Schweiz
T +41 (0)44 272 15 15
F +41 (0)44 272 18 88
E info@kunsthallezurich.ch
www.kunsthallezurich.ch